IMAGES
*of America*

# EL PASO'S
# MANHATTAN HEIGHTS

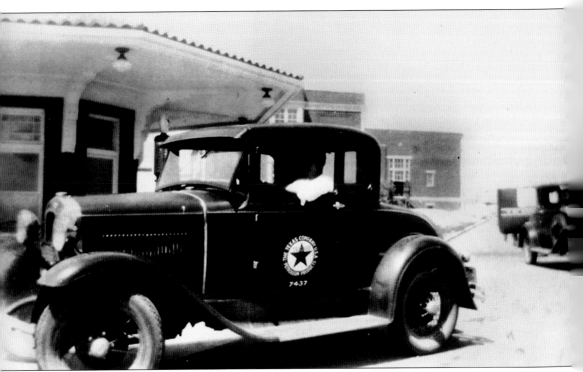

This unique gas station located at the corner of Grant Avenue and Elm Street was built in 1919, and operated as the Texas Service Station. Jack McGrath, who was attending high school at the time and selling magazines, purchased it. For 46 years it was a radio repair shop until it was sold to Rodney Davenport, after 35 years of waiting. Davenport's father, Robert Davenport, owned a gas station at the corner of Piedras Street and Richmond Avenue. Today, Rodney Davenport can be found at Davenport Antiques in Canutillo, Texas. (Courtesy of Rodney Davenport.)

ON THE COVER: An unidentified couple standing on the edge of a lily pond contemplate their future or just simply enjoy the many goldfish swimming freely. The Franklin Mountains can be seen in the background. (Courtesy of Jeanette Lewis.)

IMAGES
*of America*

# EL PASO'S
# MANHATTAN HEIGHTS

Craig M. Peters

ARCADIA
PUBLISHING

Published by Arcadia Publishing
Charleston, South Carolina

Printed in the United States of America

Library of Congress Control Number: 2011923449

For all general information, please contact Arcadia Publishing:
Telephone 843-853-2070
Fax 843-853-0044
E-mail sales@arcadiapublishing.com
For customer service and orders:
Toll-Free 1-888-313-2665

Visit us on the Internet at www.arcadiapublishing.com

# CONTENTS

# ACKNOWLEDGMENTS

When I first began this project, I was not prepared for how challenging it would be gathering enough photographs to represent the neighborhood. Most, if not all, of the original families moved away and either took their history with them or, in most cases, discarded or lost what they did have. In the beginning, I thought how difficult and how much history could there be in a district consisting of 650 homes, one school, and three churches? As I delved back into time, I found that there was an overwhelming amount of history to be discovered—as well as many gaps. Therefore, only a small glimpse of Manhattan Heights is represented in the scope of this book.

I wish to thank Jeanette Lewis for all her help, direction, early contribution of images, and review of the final product. Also, thanks go to Henrietta Reynaud Owen both for sharing stories of Manhattan Heights as it was just beginning and for seeking me out. I would also like to thank Helen Niemeier, Chris and Tatjana Lane, Barbara Light, Jan Capecelatro, Rodney Davenport, Ernest III, and Irma Serna for their images and/or suggestions, as well as Charles Maddox for sharing with me his home that is virtually the same as it was when first built.

Many of the images within this book were discovered in public and religious institutions that are the cornerstones of any neighborhood. If it were not for the El Paso Independent School District (EPISD); St Alban's Episcopal Church; First Church of Christ, Scientists; and Manhattan Presbyterian, there would not have been any chapters representing the schools and churches that served the neighborhood.

Special thanks goes to those individuals—Daryl R. Meyer, Janet W. Bartlett, David Larsen, and Rev. Katherine Norvell—who were of great assistance with their time and allowing me access to the collections. Also, thanks go to Martha Estrada and Ruth Brown from the Border Heritage Center at the El Paso Public Library along with Claudia Rivers and the staff at Special Collections at the University of Texas at El Paso, all of whom painstakingly conserve our past.

Many thanks are extended to Arcadia Publishing for the opportunity to represent one of El Paso's neighborhoods and to Lauren Hummer for her support in all matters regarding this book. Finally, thanks go to my family: my wife, Nickie, daughter Madeline, son Nicholas, who supported me in taking on another challenge, and my daughter Natalie, who helped me in creating and presenting a PowerPoint presentation that sparked the idea of representing one of El Paso's historic neighborhoods.

# INTRODUCTION

On October 13, 1980, Dr. Kenneth Bailey received a letter from congressman Bill White informing him that after much hard work and dedication the Department of the Interior's National Register of Historic Places declared Manhattan Heights El Paso's first historic district. This designation was not obtained easily, and it may have not happened at all without the handful of volunteers. Those early visionaries included Una Hill, Mary Wilson, Louis Cantwell, Mary Neil Brown, Sandra Davis and others. Due to their efforts, research, and dedication, Manhattan Heights was preserved and kept its uniqueness for future generations.

This small pocket consisting of four parcels of land surrounded by El Paso began not as a residential district but as the Federal Copper Company on June 9, 1899. Copper was experiencing a very lucrative market, and New York investors who owned copper mines in Arizona and were the largest supplier to the El Paso Smelter Works thought they could save large amounts of money and fuel processing their own ore. As with any bubble in the marketplace, it was bound to burst. As the prices in copper began to fall, so did the Federal Copper Company. Within 10 years that involved a short period of success, multiple owners, production stoppages, and huge debt, the smelter was officially shut down December 1, 1908—paving the way for the area's second life.

By 1912, the smelter was demolished, which due to El Paso's rapid growth east of downtown opened up new interest for the land as residential. Parcels 2, 3, 4, and 5 of the company's holdings were bought by Leo Dressar for $30,000 on August 6, 1907. Edward Gerrand of Indianapolis purchased parcel 1, and he would be the last owner of the smelter before selling it to J.F. and O.C. Coles on January 2, 1913. After making the purchase, they began subdividing the property into the Castle Heights subdivision of Manhattan Heights and, later, Memorial Park. Parcel nos. 2, 3, and 4, owned by Leo Dressar, was sold to local dentist James Brady, who ran a paving and construction company. This area would become the Manhattan Heights addition to El Paso. If one were to drive through the area, he would notice the streets are named Copper, Gold, Silver, and Federal. Streets outside of the Manhattan Heights boundaries are named Bisbee, Bishop, and Douglas, in tribute to the area's beginnings.

Now in its second stage of life and constituting what many considered El Paso's first true suburban neighborhood, Manhattan Heights and Castle Heights began to take shape. The uniqueness of this neighborhood was shaped by the natural terrain of the area, the smelter construction, and most importantly the architects who would design and build the grand homes for the well-to-do as well as the anything-is-possible attitudes of the early 20th century. The area consists of an eclectic combination of Georgian Revival, Southern, Foursquare, Tudor, and Spanish-Italian influences as well as American bungalows that are scattered throughout the neighborhood. The first home would be built on Federal Avenue in 1914, and most of the houses were completed by early 1930s, with sporadic building until the 1950s.

During this time of excitement and turbulent history in the first half of the 20th century, a community was created—despite the Mexican Revolution, two world wars, the 1918 flu epidemic,

and the Great Depression. In the beginning, the area, although suburban, had both a city and a rural feel to it. Amongst the large, beautiful homes, residents also had their own livestock, such as pigs, cows, and horses as well as donkeys for their children.

With clean air that was away from the noise and pollution of El Paso's Smelter Works (later known as ASARCO, which is no longer in operation), Manhattan Heights and Castle Heights were promoted to attract the elite of El Paso. Bankers, doctors, lawyers, the original developers, businessmen, architects, mayors, governors, ranchers, a future Supreme Court justice, and actresses would build and or make this small district their home.

One residence built in 1915 at 3020 Federal Avenue, which was purchased by Dr. Scurry Latimer Terrel, who was Theodore Roosevelt's personal physician during the 1912 presidential election. He attended to Roosevelt when he was shot by John Schrank on October 14, 1912. In 1917, Flint McGregor, the son of wealthy rancher John Douglas McGregor, constructed a home at 2923 Copper Avenue. The McGregors sold the ranch to the US Army, and it is known today as McGregor Range.

The home at 1501 Elm Street belonged to the father of Fred Hervey, a future mayor of El Paso, Circle K founder, and owner of the original Oasis restaurant. He spent his early childhood and teenage years in the house on Elm Street. The first female associate justice of the United States Supreme Court, Sandra Day O'Connor, lived in the home at 3113 Federal Avenue during her teenage years, and she later graduated from Austin High School. This is just a sampling of the individuals and families who contributed to both El Paso and the nation as a whole.

While the homes were being built, a portion of the land that was part of Castle Heights parcel no. 1 stayed vacant. With the tract's deep ravines, high hills, and its use as a slag dump, the only activity that could be seen was when General Pershing's cavalry officers would exercise their horses in and out of the rough terrain. Planned by renowned landscape architect George Kessler, a park began taking shape, with thousands of trees and shrubs planted in the spring of 1921. Memorial Park would reach its peak of beauty with the planting of Hill Top Gardens, which won national recognition along with two other parks—in Tulsa, Oklahoma, and Elmira, New York—out of 2,000 entries.

In 1976, a group of citizens formed the Memorial Park Improvement Association (MPIA) to preserve and restore the area. After much research of each home and the original owners that contributed to the neighborhood and to El Paso, the visionaries presented their information to the El Paso County Historical Society. This data would later be sent to the Texas Historical Commission for consideration in declaring the area a historical district.

Today, the Manhattan Heights Neighborhood Association, along with others, continues to keep the integrity of the neighborhood intact. If we do not understand those that came before us and those that lived in the homes, who were a significant part of creating El Paso and contributing to America, we could just simply consider the historic residences as old, with no meaning, and tear them down. Progress is wonderful, but without those who came before progress, there would not be any. When people go overseas, they are drawn by the romanticism of the past. With the many historic districts that El Paso now has to offer, we too can draw people to our historic past as we move into the future.

# One

# BEGINNINGS

In June 1899, a New Yorker named George Fitzgerald was inspecting land adjacent to the El Paso & Northwestern Railroad for the sole purpose of building a smelter. With articles of incorporation filed in Austin and $500,000 of capital stock from those Fitzgerald was representing, the desert east of El Paso would soon change. With plans underway, George M. Jacocks, president of the new Federal Copper Company, would begin making financial arrangements by July for the 1,000-ton smelter to be constructed.

Architects Buchanan and Allen designed the smelter and also oversaw its construction. In 1901, the project was under way with the contract for the masonry work, which was awarded to J.T. Teufenthaler. John Eubanks supplied the stone that was needed. He also constructed a tramway from the quarry on Mount Franklin to the smelter.

Once the smelter was completed, processing the ore began on September 10, 1901, and the company experienced a short period of profitability, but not for long. With a drop in copper prices and mounting debt for the firm, Leo C. Dessar would take over as president. The company was able to secure $150,000 to pay off debt; those funds, however, were used to purchase land parcels 4 and 5. A restraining order was sought and granted to the Torpedo Mining Co., and by September 12, 1903, the smelter was shut down.

In the years from its beginning to today, Manhattan Heights has been much unchanged. Most of the homes have not been radically altered, and they still retain their original character. Although, from the 1960s to the 1970s, there had been a decline, and a group of concerned citizens took action to preserve the park and surrounding areas. This led to the MPIA being formed. Historic status would be granted on June 9, 1979, to protect and revitalize a once vibrant neighborhood.

As it moves forward into the future, the Manhattan Heights Neighborhood Association (MHNA) has taken over the MPIA's original goals of educating and informing on, interceding on behalf of, and preserving the original integrity of one of El Paso's many treasures.

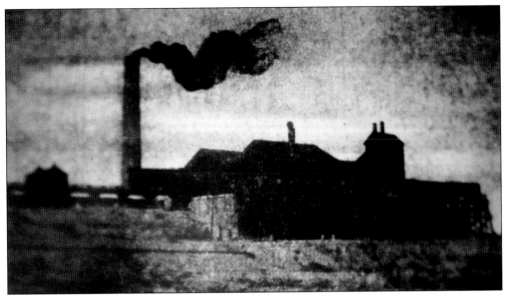

The only known image of the Federal Copper Smelter is dated April 11, 1906, when the facility was purchased by Colonel Greene, who intended to use it to smelt his own ore from his Sierra Madre Mines in Mexico. At the time, the smelter was not operational. This may be an earlier image, as Greene purchased all photographs of the smelter along with the property. (Courtesy of El Paso Public Library.)

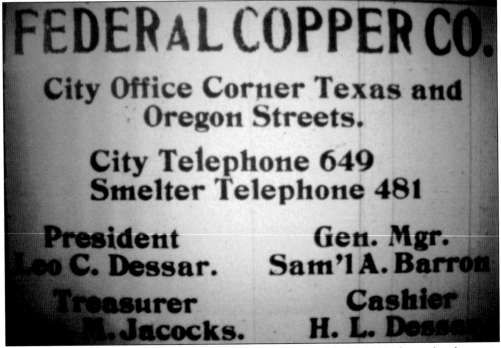

This advertisement found in the *El Paso Herald* newspaper on July 26, 1901, shows the change in leadership at the smelter. The company offices were originally located at the corner of Texas and Oregon Streets but later moved to the smelter after it began experiencing financial difficulties. (Courtesy of El Paso Public Library.)

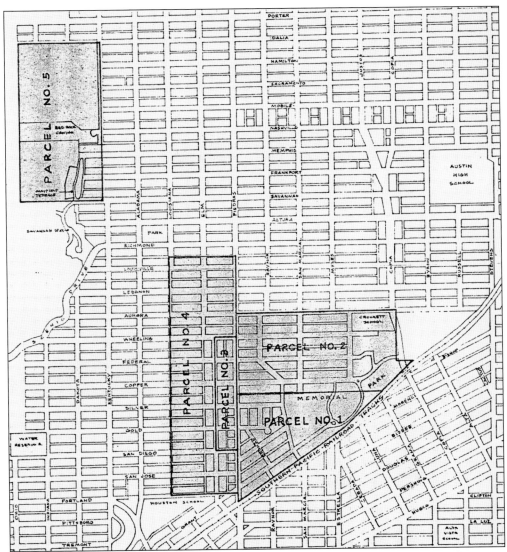

The shaded areas indicate the original smelter property obtained by the Federal Copper Company. As the acting agent for the newly formed company, David W. Payne would purchase parcel no. 1 where the smelter was actually located. George M. Jacocks, the principle investor, obtained parcel 2. Parcel 3 was purchased for railroad siding that was required for the smelting operations. In 1902, parcels 4 and 5 were purchased with money that was originally allocated to pay off debt. (Courtesy of El Paso Public Library.)

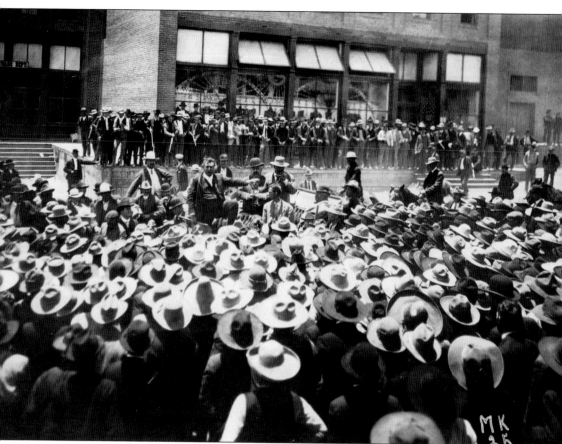

Col. W.C. Greene was not a colonel, but at the time adding a prefix to his name increased his status with New York investors. He would be the last person to own the smelter for the purpose of refining copper. Known as one of the copper kings and the founder of the Cananea Consolidated Copper Company in Mexico, Greene was also a rancher. He owned the Greene Cattle Company in Arizona and the Cananea Cattle Company in Mexico, with over one million acres of ranch land. By 1908, with the drop in copper prices, a man who amassed most of his fortune between 1899 and 1906 and was worth approximately $50 million would see his mining and lumber empire collapse. Born in 1851, Greene died on August 5, 1911, of pneumonia contracted after a carriage accident. He is pictured here (near center) addressing a crowd of striking miners in Mexico. (Courtesy of Library of Congress Prints and Photographs Division.)

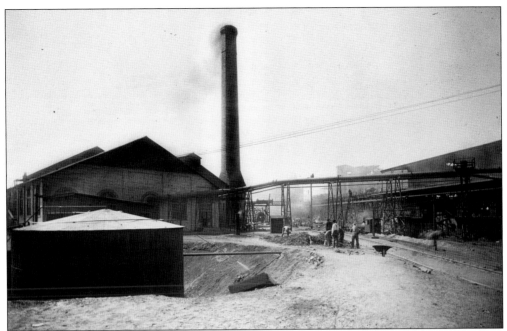

This unidentified image of a smelter in the Otis A. Aultman Collection may show the Federal Copper Company smelter. On close inspection, the features of the smokestack and buildings, although taken at a different angle, suggest it is the smelter. It employed more than 100 people when in operation and would have continued until the 1907 panic. (Courtesy of Otis A. Aultman Collection, El Paso Public Library.)

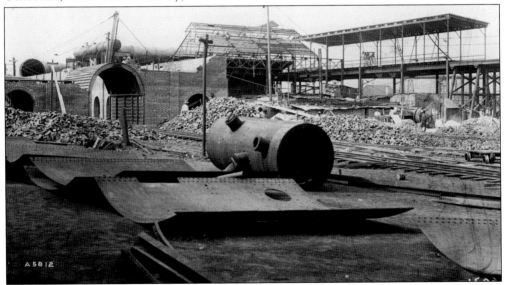

Another unidentified image shows what looks like the same smelter in the process of demolition. From 1912, the smelter buildings sat vacant for nearly 10 years. With the property within city limits, the process of removing the smelter began. Some of the equipment has been sold off years before and taken to other refineries. What may identify this image as the Federal Copper Company is the ironclad coverings that can be seen in the foreground being removed. It was reported in the *Herald* on April 3, 1912. (Courtesy of Otis A. Aultman Collection, El Paso Public Library.)

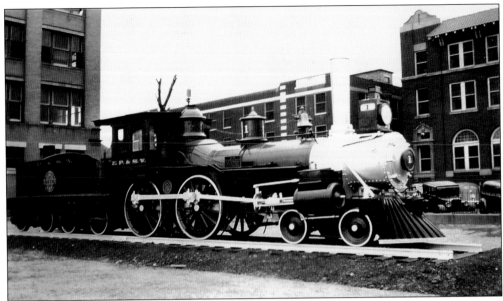

Engine no. 1 was the first locomotive to be used during the mining boom at Bisbee, Arizona. It made many trips along the El Paso & Southwestern Railroad. It was in service for 50 years and retired in 1909. This image shows the locomotive at Southwestern Pacific Park, where it was on display until 1960. (Courtesy of author.)

The two homes located at 1315 and 1401 Elm Street were built by Otto Thorman in 1915, just one year after the first house in Manhattan Heights at 3037 Federal Avenue was constructed. San Jose Avenue separates both homes. (Courtesy of El Paso Public Library.)

In 1917, this home at 3001 Copper Avenue is being built for N.N.R. by five construction workers. Notice the garage being constructed for the relatively new transportation that faces the alley. The house across the street is the Palm residence, adjacent to what would eventually be Memorial Park. (Courtesy of Jeanette Lewis.)

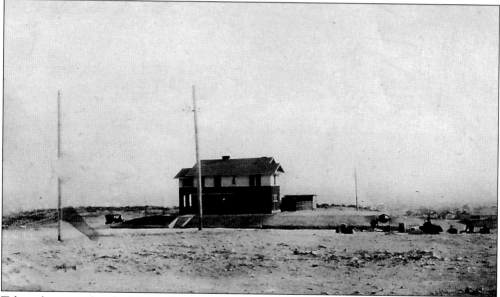

Taken the same day the N.N.R. home was being constructed, this image shows a house at 3014 Copper Avenue that was built in 1916 for O.H. Palm. Thirteen years later, it was sold to the Kerr family. The initials J.J.O. (not shown) may have been for Jay and Otis Coles and James Brady, as the Palm home is located on parcel 1, and the N.N.R. home was built on parcel 2. The Hill Top Gardens of Memorial Park were located behind this house. After construction of the first house in 1914, the area was growing rapidly three years later. (Courtesy of Jeanette Lewis.)

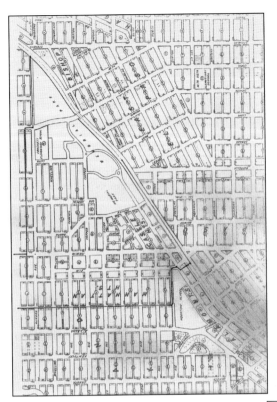

By 1979, the boundaries for Manhattan Heights Historic District (MHHD) were determined to consist of parcels 1, 2, 3, and 4 of the original property of the Federal Copper Company. Parcel 5 is a partially developed area at the base of the Franklin Mountains. The names of many of the streets inside and outside of the boundaries reflect the mining history of the area. (Courtesy of El Paso Public Library.)

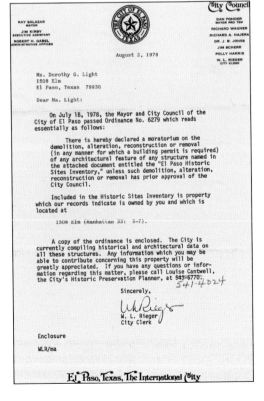

This is the letter sent in 1978 to Dorothy G. Light and other residents, in which the City of El Paso informs them that any alterations and changes to their properties must not occur while the area is under review for historic status. (Courtesy of Barbara Light.)

# *Two*

# OTTO THORMAN

Otto Thorman was considered one of the most successful architects of the Southwest by the time he was 26 years old. He was born in Washington, Missouri, on April 12, 1887, and was the son of Fredrick and Fannie Langenburg Thorman. After graduating from high school, Otto began college in St. Louis, where he later enrolled in the St. Louis Art Institute. He paid for college by working at various jobs, including gaining early experience as a draftsman. By the age of 19, he already demonstrated his abilities in his chosen field.

Otto pursued his occupation in Albuquerque, New Mexico, where he opened his first office and began designing and building many businesses and homes. By 1911, he would expand his operations by opening an office in El Paso, Texas, where he would become increasingly more successful. Within two years, he had contracts to construct the New Commercial National Bank, apartments, and many residences. In 1914, Otto would have his first home constructed in Manhattan Heights. He was known to say that El Paso "is the greatest city its size in the world," and he was glad to be a part of the development that shaped the growing metropolis in his time.

Otto Thorman's contributions can still be seen today with the examples that follow, as well as many apartment buildings, the Women's Club, the Mission Theater on Alameda Street, and the Rio Grande Theatre in Las Cruces, New Mexico. One other piece of architecture that may represent Otto's spirit and that of El Paso many years ago was his replica of the Statue of Liberty that once graced downtown El Paso.

This is an image of Otto H. Thorman later in life, many years after he designed the first home in Manhattan Heights. Most of the larger houses in the district can be attributed to him. (Courtesy of Otto H. Thorman Architectural records, C.L. Sonnichsen Special Collections Department, University Library, the University of Texas at El Paso.)

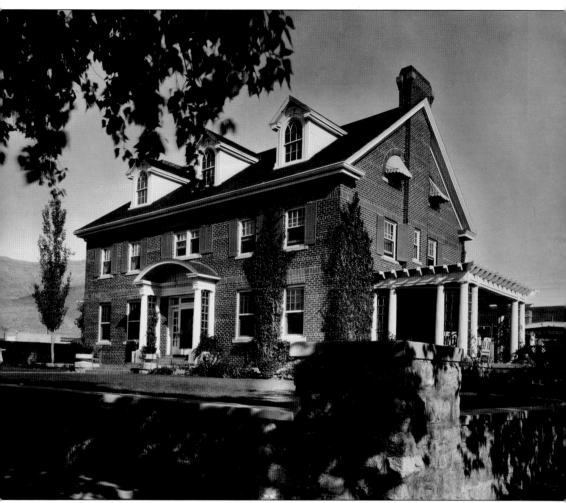

Constructed for Charles H. Leavell, this Georgian Revival at 3037 Federal Avenue was the first house in Manhattan Heights that was designed by Otto Thorman and constructed by Bischoff in 1914. Leavell was one of the original developers of the area, and his family entertained often. Gen. John J. Pershing was a frequent dinner guest and personal friend of the family. Gen. James Polk, a World War II hero, married Charles's daughter Josephine. The wedding took place in the home on November 7, 1936. (Courtesy of Otto H. Thorman Architectural records, C.L. Sonnichsen Special Collections Department, University Library, the University of Texas at El Paso.)

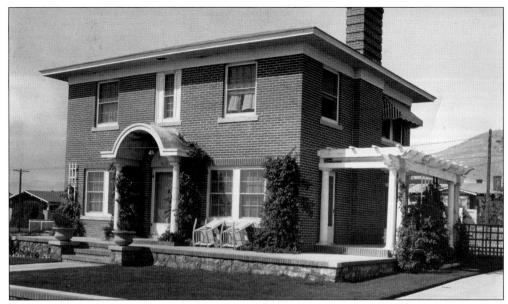

This home at 1619 Elm Street was built for C.C. Covington, the manager of Graham Paper Company, in 1919. Covington began as the office boy and retired after 60 years of service but stayed on with the company for seven more years in sales. At 77 years old, he officially retired and was known to say, "A rolling stone gathers no moss." (Courtesy of Otto H. Thorman Architectural records, C.L. Sonnichsen Special Collections Department, University Library, the University of Texas at El Paso.)

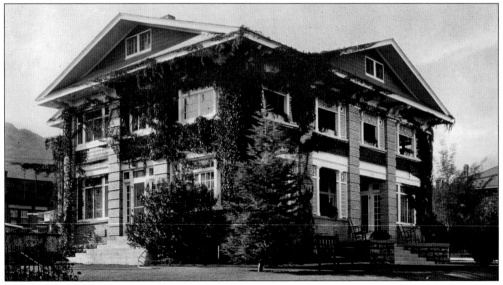

Located at 1315 Elm Street, this home was constructed for F.N. Hall in 1915. He was the president of the National Jewelry Company and a partner in Hall and Lyons Real Estate Co. In 1920, G.W. Adams, president of the National Lumber Company, purchased the residence. Marcus Snyder, a rancher and cattleman, owned the home six years later. By 1934, the structure would be known as the McBride School of Music. (Courtesy of Otto H. Thorman Architectural records, C.L. Sonnichsen Special Collections Department, University Library, the University of Texas at El Paso.)

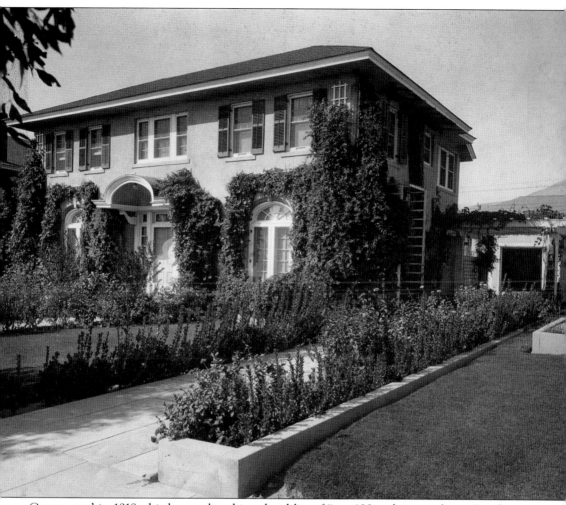

Constructed in 1918, this home placed in a local list of "top 100 architectural gems" and was first owned by A.E. Rowlands. In 1924, Crawford M. Harvey, founder of El Paso National Bank, would purchase the house, which was located at 1407 Elm Street. Maude Harvey would become the first woman to head the local Red Cross and established a local office of Planned Parenthood. Crawford was the father of Paul Harvey, who built the home at 3100 Gold Street. (Courtesy of Otto H. Thorman Architectural records, C.L. Sonnichsen Special Collections Department, University Library, the University of Texas at El Paso.)

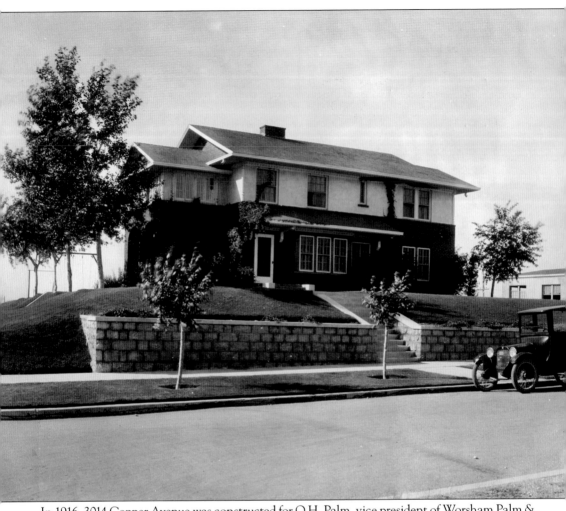

In 1916, 3014 Copper Avenue was constructed for O.H. Palm, vice president of Worsham Palm & Singleton, a local feed and fuel company. By 1930, Jay and Ruby Kerr and their sons, Cleve and Jay Alvin, would become the second occupants. In 1946, the Kerrs were running cattle on 100,000 acres in Hudspeth County leased from the University of Texas until 1977. With no phone and 50 miles away from the family home, Al, along with his brother Cleve, trained carrier pigeons to send business and family news back and forth. Ruby would live in the home until 1999. (Courtesy of Otto H. Thorman Architectural records, C.L. Sonnichsen Special Collections Department, University Library, the University of Texas at El Paso.)

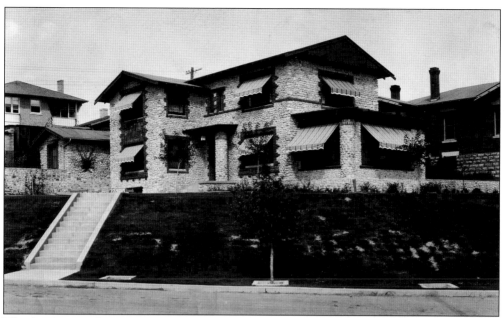

This lovely stone home at 1702 Raynor Street was constructed in 1918 for local doctor George Brunner and his wife. The small building to the left is actually built onto the house, above the garage. Some original features that are still with the home today are the fire screen, a hand-hammered copper chimney breast that was brought from Boston, Massachusetts, and a copper range hood in the kitchen. (Courtesy of Otto H. Thorman Architectural records, C.L. Sonnichsen Special Collections Department, University Library, the University of Texas at El Paso.)

In 1921, 3008 Copper Avenue was constructed for L.F. Chisenhall. (Courtesy of Otto H. Thorman Architectural records, C.L. Sonnichsen Special Collections Department, University Library, the University of Texas at El Paso.)

An example of one of the many popular bungalows in the neighborhood is 3121 Federal Avenue. This home was built for W.R. Ezel, the general manager of Standard Grocery Store and Tri State Company in the early 1920s. The stone wall contrasts texture and dimension with the smooth brick walls of the home. (Courtesy of Otto H. Thorman Architectural records, C.L. Sonnichsen Special Collections Department, University Library, the University of Texas at El Paso.)

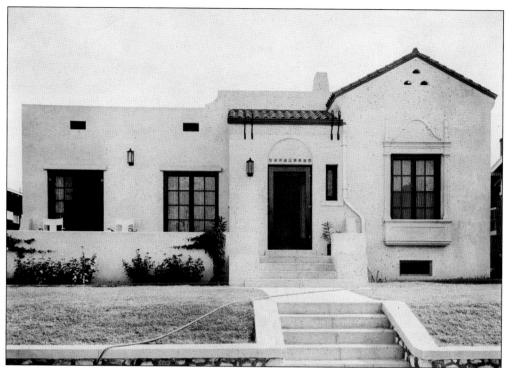

In 1921, this house at 2908 Federal Avenue was constructed for A.J. Hunter, who worked for Haymon Krupp as chief accountant and office manager. In 1924, the home was purchased for the widow of Jack Fall, son of the US senator and secretary of interior Albert B. Fall, by her mother, Mrs. M.L. Holman. (Courtesy of Otto H. Thorman Architectural records, C.L. Sonnichsen Special Collections Department, University Library, the University of Texas at El Paso.)

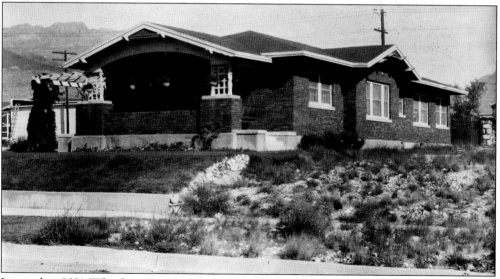

Located at 3031 Wheeling Avenue, this is another example of the many redbrick bungalows constructed in 1920 for W.S. McMath, who owned and operated the McMath Printing Company. (Courtesy of Otto H. Thorman Architectural records, C.L. Sonnichsen Special Collections Department, University Library, the University of Texas at El Paso.)

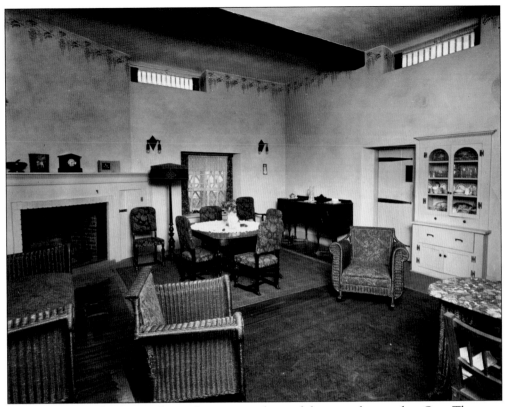

Located at 1705 Elm Street, this is the interior of one of the many homes that Otto Thorman constructed and lived in. This particular houses was completed in 1919, and one year later was sold to C.L. Ezell. In 1925, Mr. and Mrs. J.C. Galbraith, owners of Galbraith Myre Lumber Company, purchased the residence. A large ceiling beam that adorns the living room was once part of the first El Paso–Juarez Bridge spanning the Rio Grande. (Courtesy of Otto H. Thorman Architectural records, C.L. Sonnichsen Special Collections Department, University Library, the University of Texas at El Paso.)

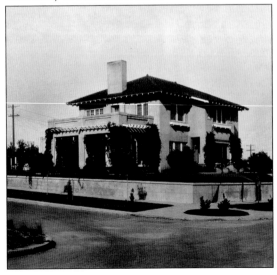

In 1916, this home at 3101 Copper Avenue was constructed for Mr. and Mrs. H.R. McClintock, the owners of the Street Car and Advertising Company. It was later sold to Hallie Bliss Robinson, widow of W.F. Robinson, mayor of El Paso, who died when a wall fell on him during a fire in downtown El Paso. Their daughter Mary Francis Robinson married Lt. (later Gen.) Terry Allen, who became famous during World War II. (Courtesy of Otto H. Thorman Architectural records, C.L. Sonnichsen Special Collections Department, University Library, the University of Texas at El Paso.)

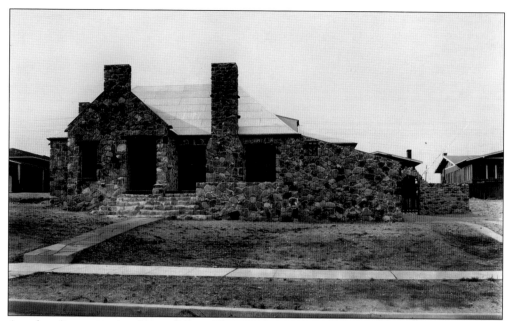

Another fine example of one of Otto Thorman's rock homes is 3137 Copper Avenue. It was constructed in 1922 for salesman Oscar Strobel, who was employed by D.C. Crowell and Company. He later would become a well-known artist who created 12 paintings in 1947 for Brown & Bigelow. (Courtesy of Otto H. Thorman Architectural records, C.L. Sonnichsen Special Collections Department, University Library, the University of Texas at El Paso.)

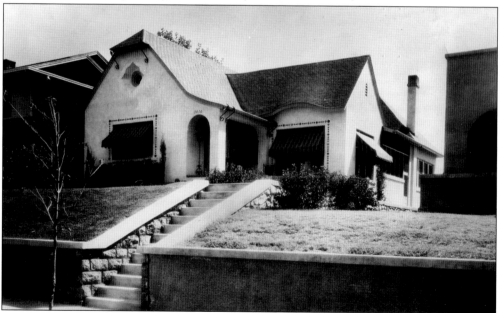

In 1921, this home at 3010 Copper Avenue was constructed for founder of Southwest National Bank, G.W. Protzman. He was also the owner of Southwestern Sash and Door Company. The house retains the original metal roof and inlaid tile decoration that adorns the windows. (Courtesy of Otto H. Thorman Architectural records, C.L. Sonnichsen Special Collections Department, University Library, the University of Texas at El Paso.)

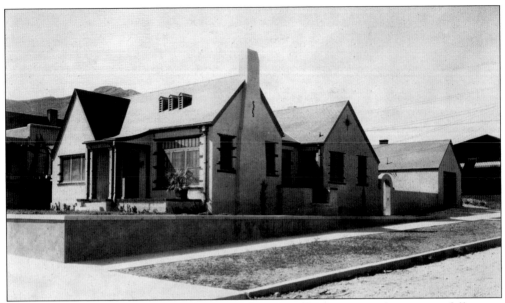

Located at 2919 Federal Avenue, this house with two small cypress trees that are now full-grown was constructed in 1923 for W.H. Johnston, vice president of EIP Bitulithic Company. From 1925 to 1927, a Mr. and Mrs. Rhodes owned the home, and it was sold in 1927 to J.C. Peyton, president of Peyton Packing Company. (Courtesy of Otto H. Thorman Architectural records, C.L. Sonnichsen Special Collections Department, University Library, the University of Texas at El Paso Library.)

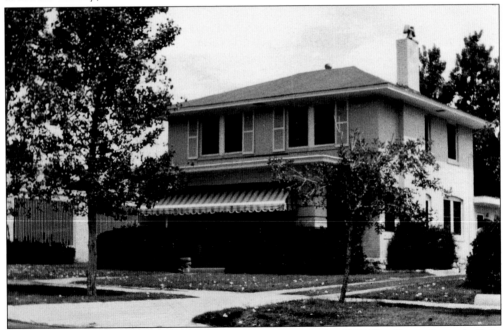

This is an example of a Foursquare home that was constructed at 1508 Elm Street. It was built in 1919 for Karl L. Hatfield, who owned and operated the Hatfield Florist, located on North Stanton Street. In 1959, a Mr. and Mrs. Light purchased the home. Mrs. Light lived in the home well into her 90s. (Courtesy of Helen Niemeier.)

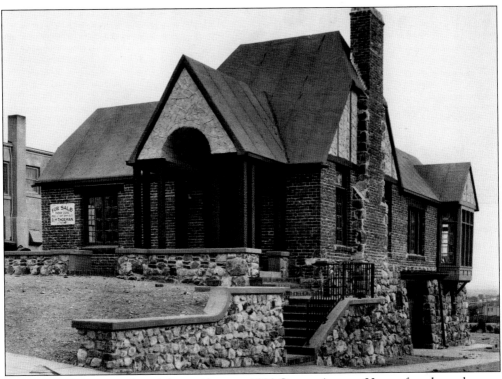

In 1922, J.S. Curtiss purchased this residence at 3000 Copper Avenue. He was founder and owner of J.S. Curtiss Mining Company, which sold oil, bonds, and stock and was established in 1912. (Courtesy of Otto H. Thorman Architectural records, C.L. Sonnichsen Special Collections Department, University Library, the University of Texas at El Paso.)

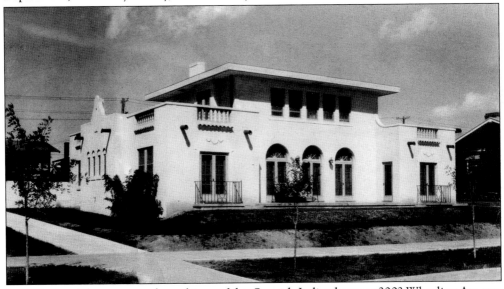

In 1922, Otto Thorman was the architect of this Spanish-Italian home at 3003 Wheeling Avenue. W.H. Peterson of Peterson Lumber Company was the first owner. (Courtesy of Otto H. Thorman Architectural records, C.L. Sonnichsen Special Collections Department, University Library, the University of Texas at El Paso.)

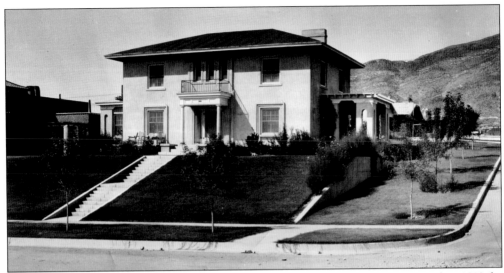

This home at 1717 Elm Street, at the corner with Federal Avenue, was constructed in 1919 for John Hicks, founder of Hicks Hayward Clothing Manufacturers, later known as Hicks Ponder. Hart Ponder, Hicks's son-in-law, merged the company with Blue Bell in 1966. Daughter Jean Hicks Richey inherited the home in 1958, and she lived in the house for 11 years with her husband, Col. Harold Richey, and their six sons. In 1959, an atomic bomb shelter that met government specifications was constructed and completed with a bedroom and bath. (Courtesy of Otto H. Thorman Architectural records, C.L. Sonnichsen Special Collections Department, University Library, the University of Texas at El Paso.)

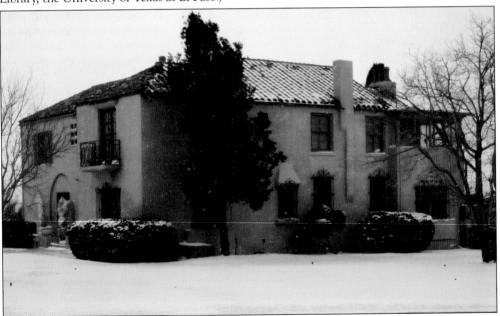

In 1926, Otto H. Thorman designed 3010 Gold Avenue, which was constructed by Ponsford Bros. for Mr. and Mrs. Frank Coles. Frank was the original developer of Castle Heights, and for those who might wonder where the original slagheap was located, this would be the exact spot. To clean the site, Frank brought out a team of mules. At one point, he stepped through an air pocket in the old slag pile. (Courtesy of author.)

# *Three*

# MABEL WELCH

One can look around all of El Paso and see the many Spanish-Mediterranean–style homes that have been constructed and that are still being constructed today. This style of architecture that changed the face of El Paso from the American bungalow to the Spanish-Mediterranean influence can be attributed to Mabel Welch. In 1927, she constructed her first home on Wheeling Avenue, and before all was said and done, 15 similar homes lined the street, with many more throughout town.

Welch was born Mabel Vanderburg on November 8, 1890, on a plantation close to Longtown, Mississippi. In 1899, she made her way to DeKalb, Texas, with her family. Here, she would meet her future husband, Malcolm Hiram Welch. During a physical examination at the onset of World War I, Malcolm would find out he had tuberculosis. Due to the diagnosis, he was advised like many others to move to El Paso because of the area's characteristic dry, thin air.

Upon their arrival to El Paso and as Malcolm's health improved, he began constructing homes. Mabel contributed as the interior decorator for each house as it was finished. They would move into the home until it was sold and move on to the next one. By 1924, Malcolm's condition worsened, and this is when Mabel began learning about the building aspects of the company and later began designing and building on her own.

As a woman, she had to overcome many obstacles. But due to her determination, desire, and a trip to California where she was exposed to the Spanish-style architecture, she found the strength to carry on. She thought this type of architecture was better-suited to the Southwest than the classic American bungalow. On her return from California, she would build her first Spanish-style home on Wheeling Avenue in 1927, which Malcolm was able to see before he died in that same year on July 17.

By 1939, Mabel was admitted to the Society of American Registered Architects, and as she was already El Paso's first woman builder, she was now honored officially as El Paso's first female architect.

In 1952, she constructed her last home but continued in the housing business by buying older homes and remodeling them for resale.

This is one of the few images of Mabel Welch, El Paso's first female architect and the second in Texas. She lived a full, productive life, designing and building many homes in El Paso. A marker has recently been placed within Memorial Park at the corner of Copper Avenue and San Marcial Street recognizing her contribution to El Paso. (Courtesy of Mabel Welch Collection, C.L. Sonnichsen Special Collections Department, University Library, the University of Texas at El Paso.)

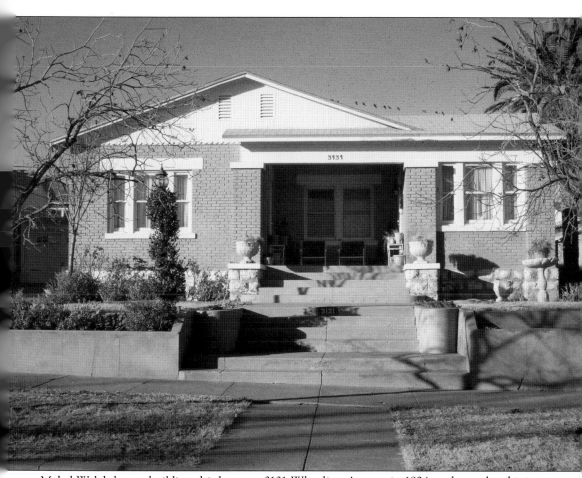

Mabel Welch began building this home at 3131 Wheeling Avenue in 1924, and completed it in 1925, while her husband was in the hospital. This was the first home constructed by her and designed in such a way that if needed, it could be converted into a duplex. This would be the family home, and Malcolm would eventually stay in the front, eastern portion of the residence, directing business until his death in 1927. (Courtesy of author.)

Mabel Welch constructed this home at 2905 Wheeling Avenue in 1927, for Mrs. C.E. Gorrochotequi, a resident of Mexico, who would bring her ill daughter to El Paso seeking a cure for tuberculosis. This is Welch's first Spanish-style home, constructed on her return from California. (Courtesy of the Blumenthal Collection at the El Paso Public Library.)

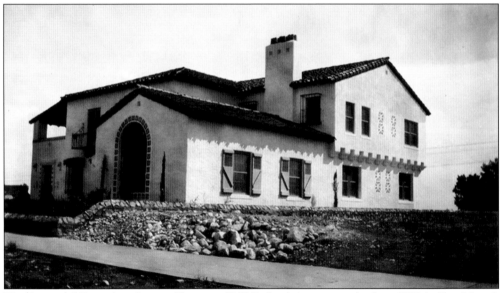

This beautiful Spanish-influenced home at 3038 Federal Avenue was built in 1929 for Roy Hoard, president of both the Ferrocarril Noroeste de México (Mexico Northwestern Railway) and the Madera Lumber Company Ltd. Upon being diagnosed with tuberculosis, he had made his way to El Paso and married Ruth Tisdale in 1922. They raised five girls and one boy in the house. Later, Dr. William J. Reynolds Jr. and his wife, along with their 13 children, owned the home. (Courtesy of Francis Jackson.)

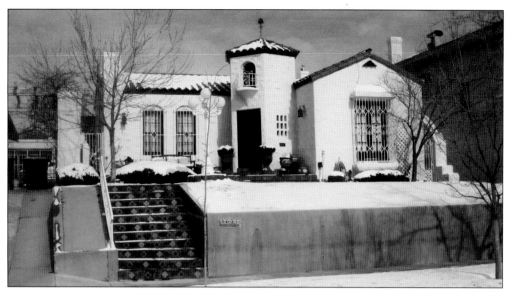

Rev. W. Angie Smith Sr., minister of Trinity Methodist Church, would be the first owner of this Spanish-Mediterranean–influenced home at 3021 Federal Avenue. He would later become a bishop of the Methodist Church in 1944. In 1928, Samuel Jackson Isaacks, whose grandfather was one of the 300 original Anglo settlers to arrive in Texas in 1821, purchased the home. Isaacks was a judge of the 70th Judicial District of Midland, Texas, practiced law in El Paso, and served from 1938 to 1954 in the Texas House of Representatives. His daughter Maude Isaacks succeeded him in the legislature and served almost 10 years. (Courtesy of author.)

Named Las Flores, 3001 Silver Avenue was constructed in 1927 for Mr. and Mrs. Sam Watkins, who owned the land on the west side of the Mount Franklin Mountains. The area was eventually developed into Coronado Country Club Estates, Coronado Hills, and many other subdivisions. Florence Watkins was at one time president of the El Paso Women's Club. This house is located in the subdivision known as Castle Heights. (Courtesy of author.)

Located across the street from Memorial Park and facing unpaved Raynor Street, this two-story home constructed in 1928 was originally owned by Castle Heights developer O.C. Coles. The second owner of the home was Ann Corzelius, the daughter of Texas oil millionaire Ira G. Yates. Ann's father was considered the richest man in Texas after discovering oil on his ranch in Pecos on October 29, 1926. The beams throughout the home, located at 3012 Silver Avenue, are from the old bridge that once spanned the Rio Grande. (Courtesy of El Paso Public Library.)

In 1918, Dr. George Tuner would come to El Paso as the chief of laboratory services at Fort Bliss Hospital and would eventually live in this home at 3009 Silver Avenue. Mabel Welch built this house, located in Castle Heights, for herself and her family in 1927. Mrs. Turner was active in many civic associations and was president of Crockett Parent Teacher Association from 1931 to 1933. (Courtesy of author.)

Completed in 1929, this Castle Heights home at 3100 Gold Avenue took nearly two years to construct. It was built for banker, investor, and rancher Paul Harvey and his wife, Katharine, who was the daughter of pioneer Zachariah Taliaferro White. Many people were involved in the design of this residence, including architect Joe Joesler of Tucson, Percy McGhee of El Paso, Charlie Oliver of Houston, George Washington Smith of California, and Mabel Welch. After the plans were completed, Welch would ultimately take the finished design and, as contractor, she would construct and supervise every aspect of the home, which was modeled after many Spanish Colonial Revival homes, such as those found in California. (Courtesy of Charles W. Mattox Jr.)

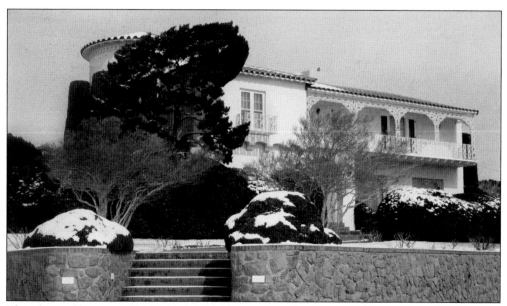

This elevated home at 3101 Gold Avenue is located in the Castle Heights section of Manhattan Heights and at the original site of the old Federal smelter buildings. The original stone foundations of the smelter remained until 1951. The house was constructed that same year for Mr. and Mrs. Sam Guido. But it would prove to be too expensive to excavate the rock foundations. The owner of the lots, Lee Sanders, constructed the rock retaining walls around the property. This is a wonderful example of Spanish-Mediterranean design. (Courtesy of author.)

This was the view into the backyard from the enclosed porch of the Hoards' home at 3038 Federal Avenue. Notice the tile work on the floor, which can be found throughout the home. The house that can be seen through the window is located at 3007 Copper Avenue. This home was owned by Dr. Willard Schuessler, a famous plastic surgeon during World War II, due to his work with the veterans of the war. After the war, he was in private practice in El Paso, Texas. His wife, Louise Schuessler, was instrumental in creating the Historical Society of El Paso. (Courtesy of Francis Jackson.)

In 1951, Mabel Welch constructed 2801 Silver Avenue for Gus Momsen Sr. The home was one of four that were constructed by Mabel that are located between Piedras and Elm Streets. Gus was president of a wholesales company of hardware and industrial supplies known as Momsen, Dunnegan, and Ryan Company. He lived in the home for eight years until his death. His wife was killed in an auto accident the year he purchased the home. (Courtesy of author.)

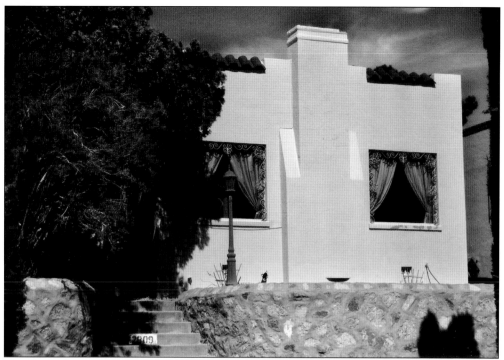

This home located at 2809 Silver Avenue was constructed in 1951 for Carl Waller Jr. (Courtesy of author.)

This home located at 2817 Silver Avenue was constructed in 1951 for Chester Henry. (Courtesy of author.)

This home located at 2821 Silver Avenue was built for Weldon B. Stromberg in 1951. It was the last of the four houses constructed between Piedras and Elm Streets. (Courtesy of author.)

Pictured here is 3100 Federal Avenue. (Courtesy of author.)

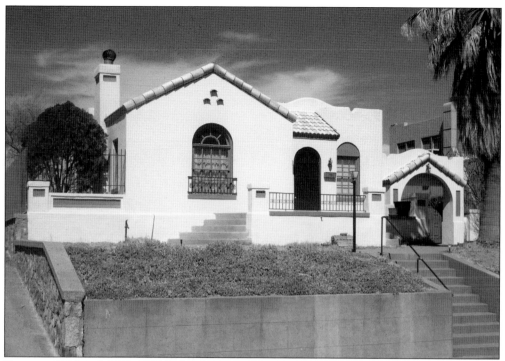

Between 1926 and 1927, 3127 Federal Avenue was constructed for C.B. Woodul, president of Woodul Coal Company. (Courtesy of author.)

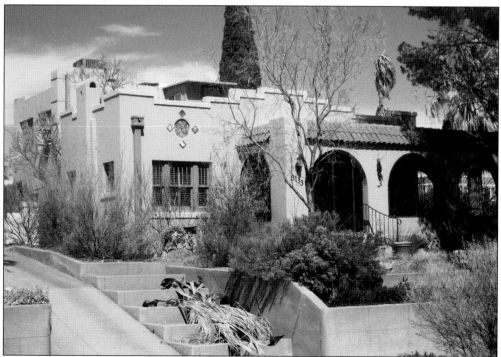

In 1927, this home at 3133 Federal Avenue was constructed for C.D. Johnson, general agent for the Texas & Pacific Railway. Johnson served in that position from 1928 to 1941. (Courtesy of author.)

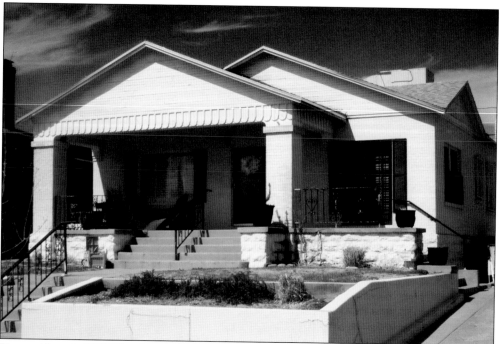

Pictured here is 3127 Wheeling Avenue. (Courtesy of author.)

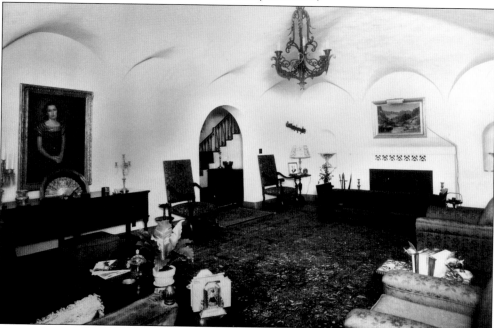

This is the interior image of the living room of Roy and Ruth Hoard in the 1920s. The room is still much as it was then. The woman in the portrait above the buffet is Ruth. The two alcoves on either side of the fireplace hold a pair of epergnes that once belonged to the Mexican emperor Maximilian and his wife, Carlotta. Francis Hoard Jackson inherited one of the epergnes from her uncle and aunt, who had raised her from the time she was seven years old. Her uncle Roy had his life threatened twice by Pancho Villa and was later spared by him. (Courtesy of Francis Jackson.)

# *Four*

# VETERANS
# MEMORIAL PARK

Built on the original grounds of the Federal Smelter Company and parcel no. 1 of the MHHD boundaries is Veterans Memorial Park, known to most as Memorial Park. In December 1919, the city allocated $10,000 to develop Castle Heights as a war memorial. On May 13, 1920, thirty acres for the park was approved by city council. Residents must thank George Kessler, one of the most eminent landscape architects in America, for its enchanted forest in the desert.

George Kessler did not live in El Paso. However, with the rapid growth of the city in the early 1920s, a plan was needed to direct its expansion. City and park planner Kessler, from St. Louis, Missouri, was called upon and persuaded to create such a plan. The work he began was not completed before his death in 1923. The stone bridges, swimming pool, tennis courts, circular walkways, and other features still seen can be attributed to his vision of what Memorial Park should be.

As the years continued, so did the development of the park. Work began for the memorial for the soldiers of the Great War, directed by city engineer W.W. Stewart, and another six acres were added.

The area of the park that would become the jewel and win national recognition was the Hill Top Gardens area. In 1933, Mrs. Albion A. Jones, second vice president of the El Paso Garden Club, contrived the idea to develop the highest area of Memorial Park into a showplace. Park commissioner Hugo Meyer had the area leveled, and rock wall seats were build as part of a Civil Works Administration project in 1933. The city's eight garden clubs all sponsored their own plots, which faced their individual districts. By 1935, the gardens were in bloom, and the Women's Department of the Chamber of Commerce and the garden club entered the Hill Top Gardens into a contest sponsored by *Better Homes and Gardens* magazine. After competing with over 2,000 other entrants, El Paso's Hill Top Gardens won first place in 1938.

The only garden still in existence within Memorial Park can be found at the northeast corner of Copia Street and Aurora Avenue in the area dedicated to the Municipal Rose Garden. The gardens were opened to the public in May 1959 and today have over 1,400 plants of 200 varieties.

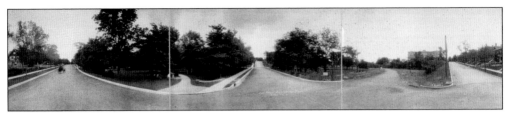

Landscape artist George Kessler was born in Germany in 1862 and emigrated with his parents as a child. He studied civil engineering, forestry, and botany in the United States and at universities in Europe. Employed at 21 years old by a landscaping firm in Kansas City, Missouri, as an architect, his reputation as one of America's most renowned landscape architect began. El Paso was fortunate to obtain his services for its own city development, which included the design of Memorial Park. George Kessler died in 1923 and never saw his designs for El Paso materialize. Pictured here is one of Kessler's most important early works, Hyde Park in Kansas City, Missouri. (Courtesy of Library of Congress Prints and Photographs Division.)

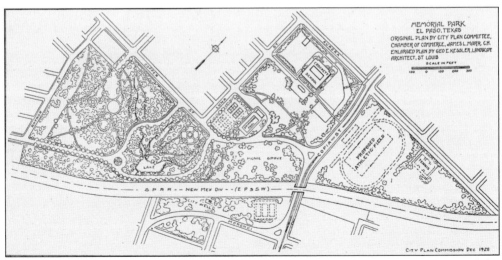

This is part of what is known as the Kessler plan, showing what George Kessler envisioned the Memorial Park should look like. El Paso was one of the few cities at the time that advocated or had any zoning codes. Kessler was responsible for zoning, as he designed and planned the growing city. The portion of the park south of the railroad tracks was designed to make the park accessible to more of the area's residents. (Courtesy of author.)

This image shows Memorial Park after just three years of growth following the planting thousands of trees and shrubs. The unpaved road is Grant Avenue, which bends around the park and straightens out in the background as it continues into Piedras Street. The Five Points area can be seen to the left of the photograph. To the upper right is the high point that slopes upward and would eventually be the Hill Top Gardens area. With the beginnings of the park seeded, the progressive nature of the city established with the services of landscape architect George Kessler, and as the city plan states that "because nature has denied her the natural attractions of grass and trees found in a humid climate," an oasis arose from the desert. (Courtesy of author.)

## City Plan Committee Aids Development of Memorial Park

### By W. E. Stockwell
#### Engineer, City Plan Commission, El Paso, Texas

WHEN the City Plan Committee of the El Paso Chamber of Commerce was organized in 1920, its first activity was the development of the parks. The city had owned for several years a tract of about 25 acres of rough desert land, irregular in shape, along the tracks of the E. P. & S. W. Railroad and adjoining a good residential neighborhood. This was renamed Memorial Park, and a plan was prepared for the part which is now the west half, as shown by the accompanying plan.

As the work of grading and planting progressed under the direction of the Committee, interest in the project grew, and more land was gradually acquired, until the area of the park is now nearly twice that of the original tract, the final boundary on the north joining the property of the Crockett School and adding to its recreational facilities. The present park extends over one-half mile along the railroad and includes two fractional blocks south of the tracks, purchased to extend the benefits of the park to the residents of that section on and to give better access to the Copia Street undercrossing by means of diagonal roads in the park.

This crossing under the tracks was shown on the original plan of the park and is distinctly a city planning achievement. The trolley tracks went under the railroad near this point on a private right of way, but the narrow passage on a curve and a steep grade was dangerous and the drainage was bad. It was proposed to open the street and carry the trolley over at grade, but this was prevented by the influence of the late George E. Kessler

of St. Louis, who was then the planning consultant for the city. Copia Street is destined to become an important thoroughfare and is now being paved through the park.

Several thousand trees and shrubs were planted in the spring of 1921 and are now sufficiently grown to furnish some shade and to make the park attractive. A concrete swimming pool 50 x 120 feet was completed a year ago and has been very popular. City water is used, and is changed as often as necessary to keep the pool sanitary. The pool empties

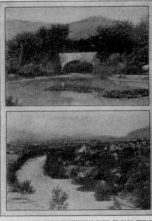

TWO CHARMING VISTAS IN MEMORIAL PARK, EL PASO, TEXAS. THE LOWER PHOTOGRAPH SHOWS THE GROWTH OF TREES AND SHRUBBERY THREE YEARS AFTER PLANTING.

The following two images are the publication of George Kessler's plans for Memorial Park by then city planning engineer W.E. Stockwell after Kessler's death in 1923. El Paso was fortunate at that time to be in the position to create parks such as this one, because officials either obtained the land needed in trade or gifts or purchased it when land was relatively cheap. The City Plan of 1925 was looking to the future as the city grew and was prepared to make it the "most beautiful park in the city." Planners felt it was "worth any reasonable investment of public money through the years" to achieve "maximum beauty with maximum use." (Courtesy of author.)

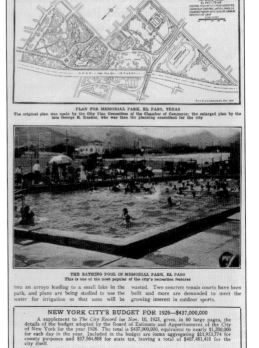

THE AMERICAN CITY MAGAZINE for JANUARY, 1926

PLAN FOR MEMORIAL PARK, EL PASO, TEXAS
The original plan was made by the City Plan Committee of the Chamber of Commerce; the enlarged plan by the late George E. Kessler, who was then the planning consultant for the city

THE BATHING POOL IN MEMORIAL PARK, EL PASO
This is one of the most popular of the city's recreation features

into an arroyo leading to a small lake in the park, and plans are being studied to use the water for irrigation so that none will be wasted. Two concrete tennis courts have been built and more are demanded to meet the growing interest in outdoor sports.

### NEW YORK CITY'S BUDGET FOR 1926—$437,000,000
A supplement to *The City Record* for Nov. 10, 1925, gives, in 80 large pages, the details of the budget adopted by the Board of Estimate and Apportionment of the City of New York for the year 1926. The total is $437,000,000, equivalent to nearly $1,200,000 for each day in the year. Included in the budget are items aggregating $11,953,774 for county purposes and $17,564,808 for state tax, leaving a total of $407,481,418 for the city itself.

Page two of the publication shows the Kessler plan for Memorial Park and the pool that was built in 1924; it was later made larger in 1936. An area across the street from the pool is now the site of the El Paso Public Library, built on what once was a cactus garden. In December 1923, a chain gang of 85 men had gone to work terracing the hill and planting cacti that were collected from the foothills of the Franklins. (Courtesy of author.)

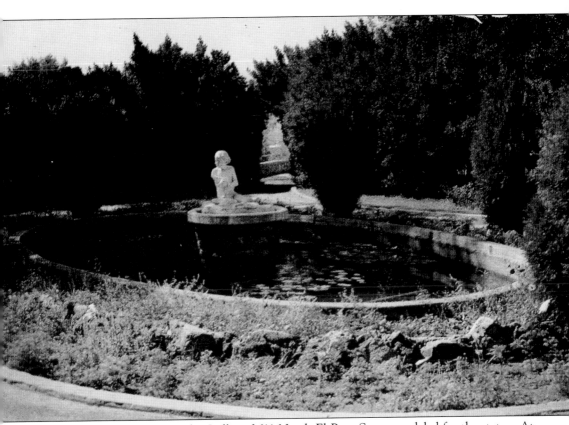

In 1936, nine-year-old Dorothy Sadler of 611 North El Paso Street modeled for the statue. At her feet are fish that spouted water from their mouths. Sculptor Don La Marr was lent by the Works Progress Administration and had a studio at 615 North El Paso Street just doors away from Dorothy's home. He spent six months working on the project. This image was taken sometime in the 1960s or 1970s, as the Hill Top Gardens area lost some of its luster. To curb some of the destruction of the park by vandals in the early 1970s, Mayor Fred Hervey added police mounted on horseback to patrol the area. The horses were stabled near Washington Park, and the officers would ride up Copia Street and make it a point to pass Crockett School, where the children could see and pet the horses. (Courtesy of Jeanette Lewis.)

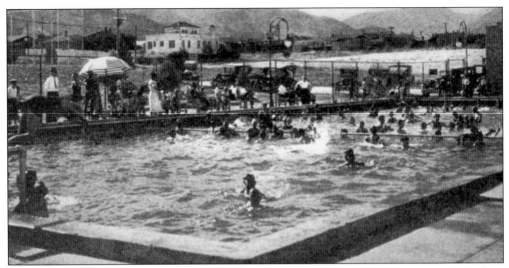

Built around 1924, the Memorial Park pool became a favorite attraction in the city. By 1936, plans were made to double the capacity due to its popularity. It was not until after World War II that a filtration system was added to the pool so it would be drained into the park near the arched footbridge and refilled on Mondays. The two-story white house in the background at the corner of Federal Avenue and Luna Street and was previously owned by the McGregor family. The area next to the pool is the upper park in front of Crockett Elementary School. (Courtesy of author.)

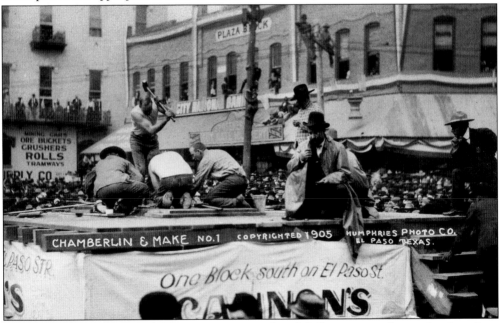

Men from all over came to El Paso to compete in a hand-drilling contest during the American Mining Congress Convention in November 1905. People of all nationalities, including Italians, Bohemians, Irish, and Slavs, were present to compete for the $1,000 prize. The contest took place in Pioneer Plaza near the Hilton Hotel. The rock is a large piece of Gunnison granite, one of the hardest rocks found in America, brought all the way from a Colorado quarry. (Courtesy of Leon C. Metz Papers, C.L. Sonnichsen Special Collections Department, University Library, the University of Texas at El Paso.)

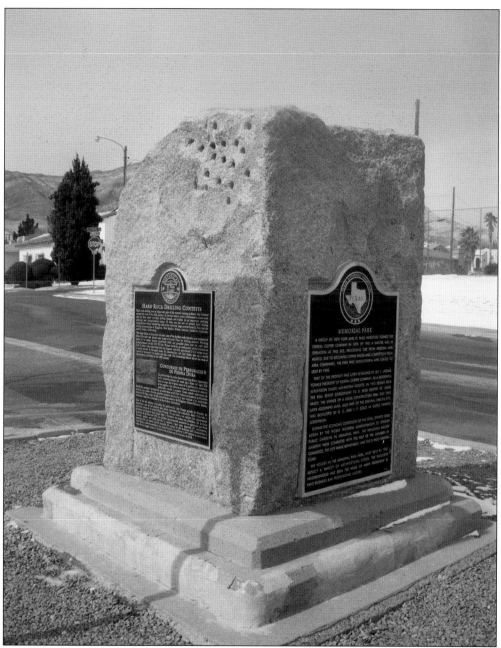

Located at the corner of Grant and Copper Avenues stands the piece of granite used during the 1905 drilling competition and which today serves as a war memorial for men lost during World War I. The holes are the drill marks from the men who competed in the contest, with only three-sixteenths of an inch separating the first- and second-place winners. The rock was discarded after the contest and taken to City Hall Park and made into the memorial. Park superintendent Hugo Meyer rescued it from being discarded a second time and created a permanent memorial. Although new plaques have taken the place of the original list of names, the marker still commemorates the 70 men who fought and lost their lives in the Great War. (Courtesy of author.)

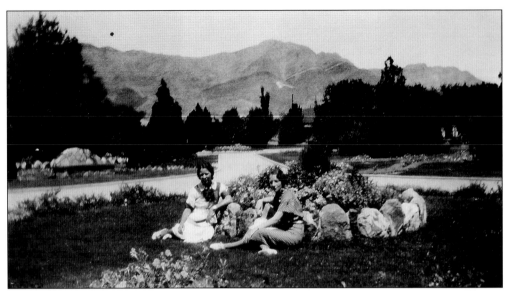

Two unidentified young women pose at one of the many gardens that once adorned the Hill Top Garden area. There were eight individual gardens, each sponsored by its respective garden club. This once rocky area would go on to win national recognition along with two other community projects in the nation. One of the lovers' benches is to the left, and one of the rock wall paths that leads down to the lower area of the park can be seen between the trees to the right. An A for Austin High School is visible on the Franklin Mountains in the background that at one time was the most lettered mountain in the world. (Courtesy of Jeanette Lewis.)

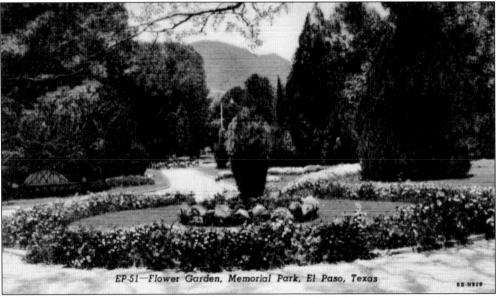

EP-51—Flower Garden, Memorial Park, El Paso, Texas

Shown in this postcard is a later view of the same spot where the ladies are sitting in the previous image. One can tell how the elm, cottonwood, ash, pine, juniper, and cypress trees grew to fill the area and make a true oasis. With numerous evergreens, it gave the otherwise brown desert a splash of green even during the winter months. On summer days, this became a refuge from the heat as mothers took their children here so they could sleep or play in the cool shade of the trees. (Courtesy of Tony Lewis.)

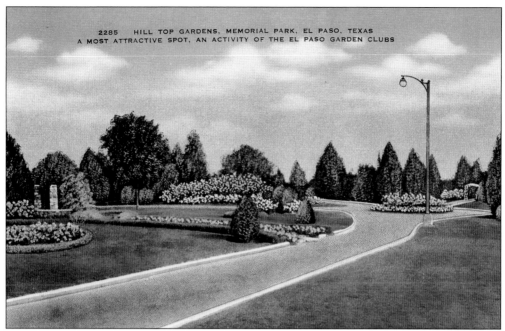

This postcard shows an area directly to the right of the previous images that has a rock wall path down to the lower levels of the park. To the far right is one of the flower-covered arches that many walked under as they leisurely traveled the many paths that would direct visitors to each of the eight gardens. Park watchman L.O. Vermillion would come across tourists from all parts of the country, almost every state, who came just to visit a beautiful park located in a desert setting. (Courtesy of Tony Lewis.)

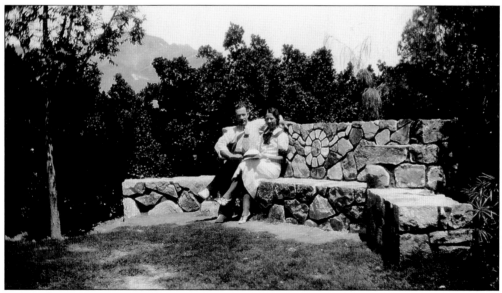

One of the women from the photograph at the top of page 50 is seen here with a male companion on one of the lovers' benches, which were located throughout the gardens. Many young couples would go to the park and take walks through the gardens, where they would find a bench to sit and talk. (Courtesy of Jeanette Lewis.)

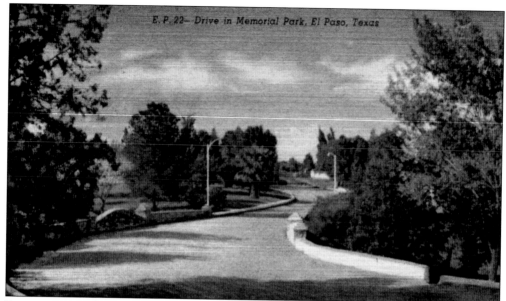

*E. P. 22— Drive in Memorial Park, El Paso, Texas*

For many years, this road was open through the park where visitors could enter through Copper Avenue, exit on Grant Avenue, and make a left or right and go back around if they wished. Today, all that is left of the road is the rock walls on either side. There is a double row of pine trees planted that one can walk through that traces the drive to this area. The road eventually was dug up because of the traffic problems it created as well as unsavory elements. (Courtesy of Tony Lewis.)

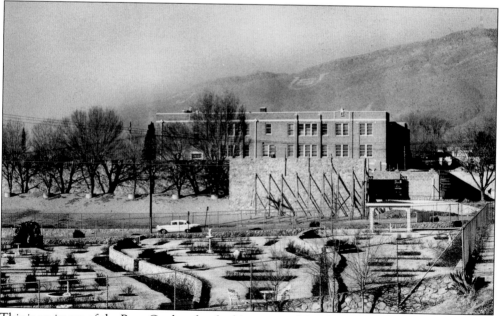

This is an image of the Rose Garden that had its start on May 6, 1958, with the planting of 250 rosebushes. Taken sometime in 1963, this picture also shows the first expansion in progress at Crockett Elementary School. Today the rose garden has many more varieties of roses and plants throughout. It is also much larger, as it went under an expansion a few years ago. The rock structure to the left with a small statue underneath still stands in the same place. (Courtesy of EPISD.)

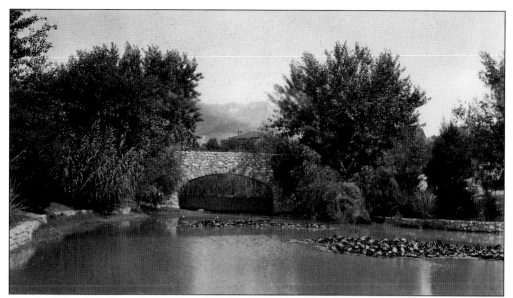

This bridge, with many of the other elements in the park, is just another example of one of the architectural features in George Kessler's plan. The lake, which would seem to be a mirage in the middle of the desert, is a true oasis that actually had a source. The pool that was built across from Copper Avenue and Luna Street was drained once a week and refilled with freshwater, as filtration and chlorination had not been developed at that time. The standing water created a lush environment for lily pads, pampas grass, salt cedars, and other vegetation. (Courtesy of Jeanette Lewis.)

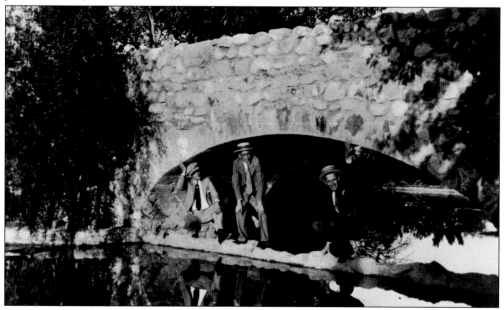

A group of men are enjoying a summer day under the bridge out at the lake. The park was a very popular place to spend hot afternoons and early evenings. People from downtown, apartments, and surrounding homes would bring their quilts and spend the hot evenings sleeping in the park, going home only after the night air cooled. The bridge still exists today, though the lake does not. (Courtesy of El Paso Public Library.)

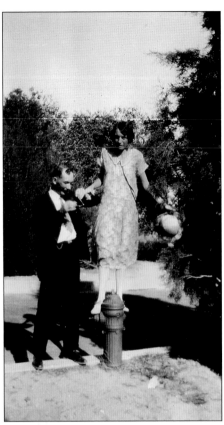

An unidentified couple is generating some entertainment on a fire hydrant in the Hill Top Gardens area. The woman does not look amused at being part of the little circus she finds herself in. This was a popular place for couples in love. Although the park always had its share of vandals, when all security was ended to save money in the 1960s, that was the end of Hill Top Garden. Many of the shrubs and evergreens were taken out due to the unsavory elements running rampant in the park. (Courtesy of Jeanette Lewis.)

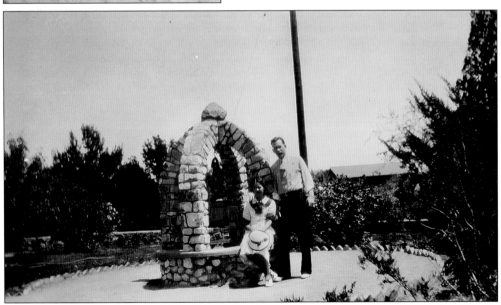

An unidentified couple poses near one of the eight gardens with a water well as the centerpiece. This wonderful structure that once graced the gardens became a victim of vandalism. Although today the gardens are gone, the Hill Top area is still hidden away with its rock walls, pathways, grass, large shade trees, and a few lovers' benches. (Courtesy of Jeanette Lewis.)

# *Five*

# MANHATTAN HEIGHTS SCHOOL (CROCKETT ELEMENTARY)

Crockett Elementary, formerly known as Manhattan Heights School, can trace its beginnings to May 2, 1916, when the school board approved the purchase of block 12 for $20,000. It was not until December 16, 1919, that construction began, with architects Messrs, Beutell, and Hardie and contractor Robert E. McKee. Manhattan Heights School opened its doors 11 months later with 360 students and eight teachers. Classes would take place on the first floor as construction continued on the second floor. The school would have its name changed from Manhattan School to Crockett Elementary in honor of those who gave their lives for Texas to be free. Therefore, when classes resumed in September 1922, returning students had a school with a new name. The enrollment dropped from 785 to 486 students after Austin Junior High School opened its doors on Grant Avenue to relieve congestion at Crockett.

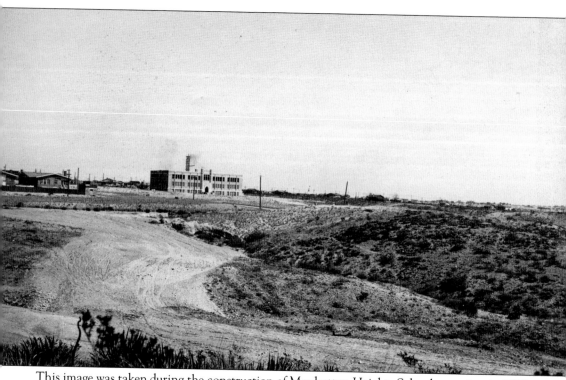

This image was taken during the construction of Manhattan Heights School sometime in 1920. By 1922, the school would be renamed Crockett Elementary in honor of David Crockett, pioneer and hero of the Alamo in San Antonio. A large crane can be seen behind the school. To the left is Luna Street, and the road toward the center is Copper Avenue; many of the homes would later be built at this intersection. This is also near the time when Memorial Park was just undergoing grading and planting. Most of the surrounding land that is seen would eventually be part of the park. (Courtesy of El Paso Public Library.)

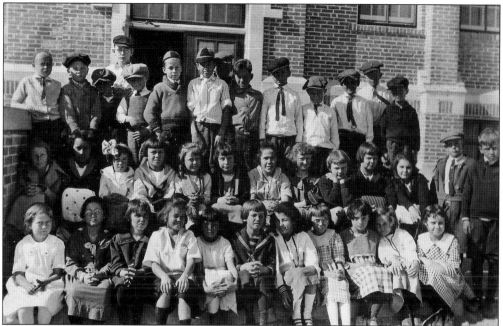

This early class photo was taken when Crockett Elementary was originally known as Manhattan Heights School. Mrs. Jackman's class is sitting at the west entrance to the building. Two childhood friends, Henrietta Reynaud (second row, third from left) and Carol Wade (first row, fourth from left), both with large bows in their hair, can be seen. Carol would later be the wife of C.L. Sonnichsen, a professor and local historian in El Paso. Henrietta remembers when Carol would come over to her house with her donkey and they would go riding through the neighborhood. (Courtesy of Henrietta Reynaud Owen.)

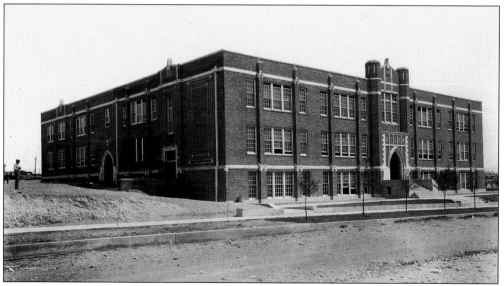

When the building opened, only the first floor was completed, with 18 rooms to serve the children of the growing area. The first principal was Alice Fitzpatrick from 1920 to 1921, and who would later marry and not return for the next school year. Three more principles would serve until Alicia Swann took over in 1923, and remained for 25 years. (Courtesy of Jeanette Lewis.)

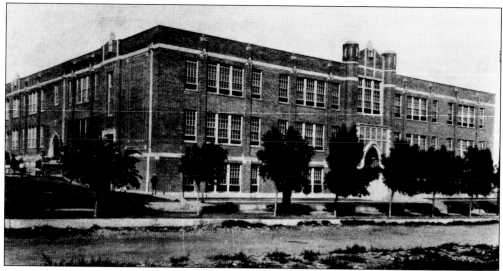

This image from a publication in November 1926, representing the El Paso Schools, shows the trees maturing and the grass-covered grounds. By this time, the top two floors had been completed, with 18 to 29 rooms and one auditorium. An enrollment of 1,000 students from kindergarten through seventh grade filled the school. It was built around a central patio with classroom windows overlooking the evergreens, flowers, and grass below and the English ivy that later clung to the walls. (Courtesy of EPISD.)

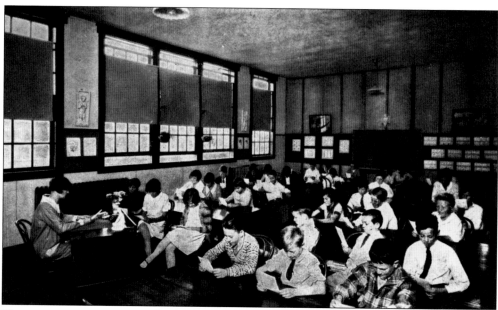

The arts were as important in the early history of El Paso schools as they are today. An unidentified teacher is pictured here with her art class sometime during the 1920s. Many plaster casts that are on the wall could be found throughout the school. Today, one can go into the auditorium and see many examples that still exist. (Courtesy of EPISD.)

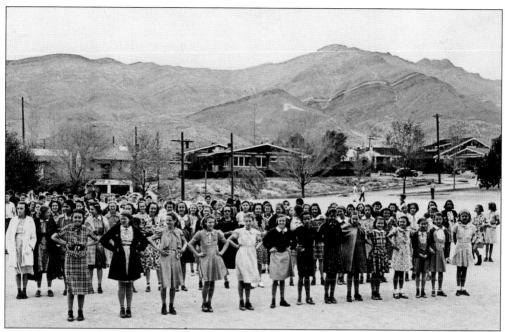

This picture of girls at the school was taken sometime during the 1930s, as some of the homes along Luna Street behind the students had not been built. The home with the car parked to the left of it is 3201 Aurora Avenue. The house to the left is on the corner of Luna Street and Wheeling Avenue. (Courtesy of EPISD.)

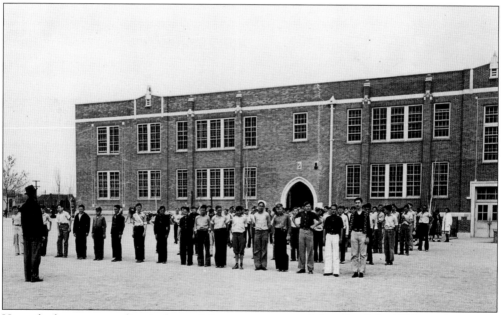

Here, the boys are standing in front of the west entrance of the school. In 1922, a cafeteria was opened in the domestic science department which served hot lunches until a cafeteria was built in the basement a few years later. Every item cost 5¢—from the sandwich to Price's milk. The Tudor-style house near the corner of the school is located on Lebanon Avenue across from Copia Street, which at one time was named Park Avenue. (Courtesy of EPISD.)

CROCKETT

PARENT-TEACHER ASSOCIATION

ORGANIZED JANUARY 1921

El PASO, TEXAS

1952        1953

Organized in 1921, the PTA took an active part in beautifying the school grounds and maintaining a cohesive structure between home and school. A Founders Day tea was held every year in the courtyard of the school. On February 13, 1953, the guest speaker was Mrs. Hugo Meyer, wife of park commissioner Hugo Meyer. (Courtesy of author.)

Each president served one school term. Mrs. O.H. Palm was the first who lived at 3014 Copper Avenue and whose husband was vice president of a local feed and fuel company. Mrs. George Brunner lived at 1702 Raynor Street. Mrs. Charles Leavell's family built the first home in Manhattan Heights at 3037 Federal Avenue. The family of Mrs. R.B. Homan Jr. owned the Homan Sanatorium and lived on Copper Avenue. These are just a few examples of the many people who dedicated their time and resources to ensure the welfare of the school and students. (Courtesy of author.)

## PAST PRESIDENTS

| | |
|---|---|
| Mrs. O. H. Palm | 1921 |
| Mrs. George Brunner | 1921-22 |
| Mrs. E. C. Wade | 1922-23 |
| Mrs. George Evans | 1923-24 |
| Mrs. Victor Anderson | 1924-25 |
| Mrs. Charles Leavell | 1925-26 |
| Mrs. John Clary | 1926-27 |
| Mrs. Hugo Meyer | 1927-29 |
| Mrs. W. E. Casteel | 1929-31 |
| Mrs. George Turner | 1931-33 |
| Mrs. E. W. Wotipka | 1933-35 |
| Mrs. R. A. Nelson | 1935-36 |
| Mrs. M. L. Burleson | 1936-37 |
| Mrs. Tom Davis | 1937-38 |
| Mrs. H. S. Lide | 1938-39 |
| Mrs. J. H. Jagoe | 1939-41 |
| Mrs. R. P. Lankford | 1941-42 |
| Mrs. J. J. Kaster, Jr. | 1942-43 |
| Mrs. Don Thompson | 1943-44 |
| Mrs. Carl Hertzog | 1944-45 |
| Mrs. J. Leighton Green, Jr. | 1945-46 |
| Mrs. R. B. Homan, Jr. | 1946-47 |
| Mrs. Robert H. Hoy | 1947-48 |
| Mrs. R. Neill Walshe | 1948-49 |
| Mrs. T. S. Curry | 1949-50 |
| Mrs. Trevor McNutt | 1950-51 |
| Mrs. Dean Earp | 1951-52 |

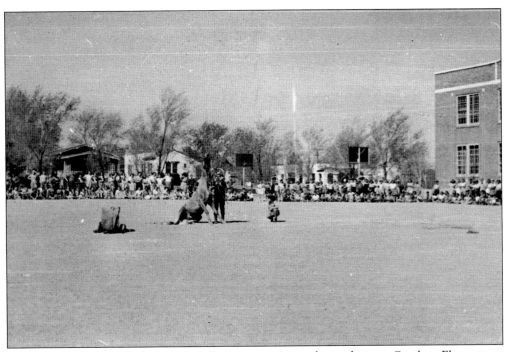

An undated photograph shows a trick horse entertaining the students at Crockett Elementary. At one time, many residents had horses in their backyards. The entire school was completely surrounded by beautiful trees, which made it a welcoming environment for the students and the community. The homes in the background face Aurora Avenue, which was once named River View Avenue. (Courtesy of EPISD.)

Within a short period of time, this area was changed from what was El Paso's wild frontier of cactus and rock into a modern suburb. It was also where General Pershing's cavalry exercised and ran drills with their horses. To the right are the evergreens that once graced the corner of Aurora Avenue and Luna Street. The houses with the addresses of 3140, 3131, 3201, and 3205 Aurora Avenue can be seen. (Courtesy of EPISD.)

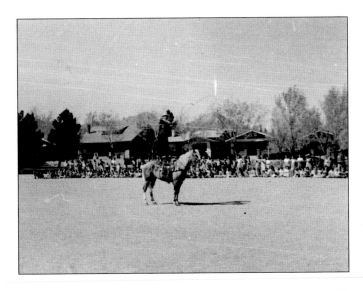

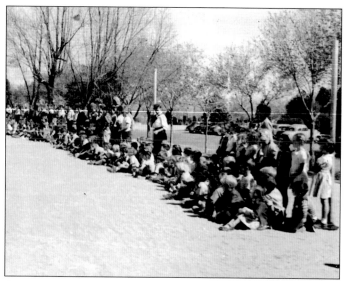

Younger students watch the same horse show from a different vantage point at the southwest corner of Crockett Elementary. The road behind them is Wheeling Avenue, which dead-ends near the school. In this springtime image, the trees appear to be budding in an oasis in the desert. Crockett was part of George Kessler's original plan for Memorial Park, which the front of the school faces. (Courtesy of EPISD.)

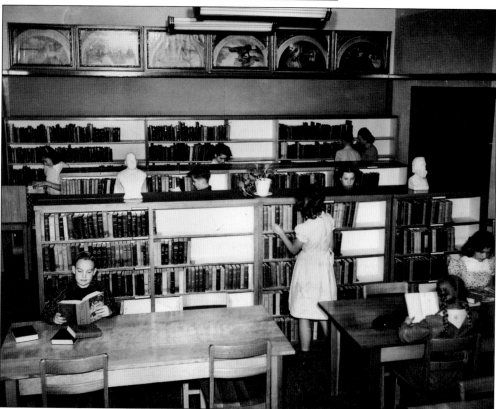

Surrounded by busts of famous writers along with artwork on the wall, students are enjoying the library. The paintings may have been six of 39 that principal Alicia Swann bought with money raised during an art exhibit sponsored by the school. Many of the books were purchased using funds earned from sales in the school cafeteria. One early report indicates that of the $567.02 made that year, $313.23 was used to purchase books. The remaining income bought slides, assembly books, a curtain, a mirror to be placed in the sewing room, and a Victrola. (Courtesy of EPISD.)

As students enter the school, they pass through a stained glass window that rises from floor to ceiling. It is in memory of the men and women who had attended Crockett and gone on to serve in the armed forces. Dedicated on May 8, 1945, it is composed of 25 sections and 30 medallions and depicts the different service branches, with their insignias representing those who gave their lives so Americans could enjoy a democratic way of life. An inscription reads, "We live in the lives of those we love; we do not die." Principal Swann had been saving for the memorial since the day Pearl Harbor was attacked. Funds were raised from school programs, cafeteria profits, and a donation from Robert E. McKee. Ralph Baker of Baker Glass was responsible for constructing the stained glass memorial as well as helping with its design. (Courtesy of EPISD.)

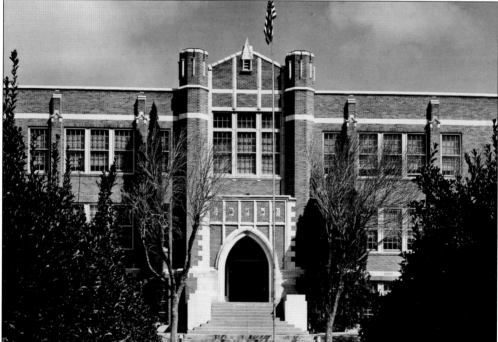

Above the stained glass entrance are five terra-cotta shields that were part of the original design of the school when it was constructed. The architects felt that these would represent a small fraction of the ideals that people should be aiming for in life. From left to right are a Roman battle ax with staves representing courage, an open book with the rising sun signifying learning, a fleur-de-lis on a checkered background representing loyalty, a cogwheel reminding one of the industrial spirit that one must have that represents an indispensable part of industry, and a single star and diagonal strip that motivate one to strive for high ideals in life. There is a sixth shield at the side and rear entrances of the building with a football and Greek lamp indicating that physical health and sportsmanship are part of knowledge and not separate from it. (Courtesy of EPISD.)

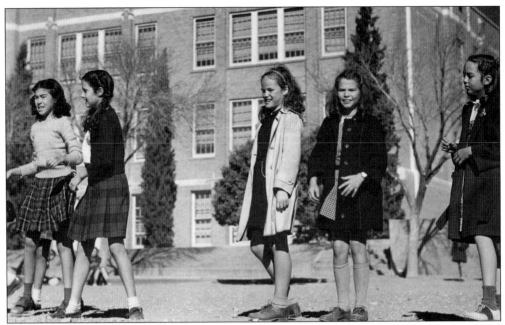

In the winter of 1947, the year before principal Alicia Swann retired, she received a phone call from Lois M. Godfrey, who was the counselor for the German scientists and their families who were relocated to Fort Bliss after World War II to conduct rocket research. Due to its location near Fort Bliss, Crockett seemed to be a good choice for the 90 children who arrived in April from Germany. Since many parents, relatives, and siblings had fought and died in both world wars, many concerns arose about how locals would receive the German children. Some of the German students never attended school, and two-thirds could not speak English. By the time the new year began, Swann's fears were put to rest as she stood at the entrance and watched as all 936 of the American children (including the German students) whom she knew by name walked through the door. The students pictured are, from left to right, unidentified, Kay Atkins, Anneliese Eisenhardt, Annamarie Hey, and Nancy Jo Caffey. (Courtesy of EPISD.)

Alicia Swann is quoted as saying, "They are not our German children . . . . They are our American children. In spirit and in thinking they are American, for they have happiness here they have never known before. You can see it in their faces." To get the children ready and acclimated to the American school system, a summer school was opened in one of the unused hospital wards in town. The parents of the children painted, built partitions, and constructed a playground. The El Paso school district supplied classroom furniture. Teachers volunteered for 10 weeks to teach the children English, without an interpreter and using pictures, songs, and rhymes to diminish the language barrier enough before classes started in September. (Courtesy of EPISD.)

## *Six*

# SURROUNDING SCHOOLS

What was known as the east side of El Paso began growing rapidly, and a separate junior high was desperately needed. Austin Junior High School began classes in September 1922, relieving over crowding at Crockett. Located on Grant Avenue, the school now known as Houston School of Choice, formerly Houston Elementary, was designed by Henry Trost and constructed by Vernon E. Ware Construction Company. High above Grant Avenue, the steps to the front entrance remind one the importance of gaining an education.

During later years, the school served many of students as Austin High School until September 1930, when a new Austin High School would open its doors. Construction on this high school began in 1929, and it was designed and built by R.E. McKee.

Before high schools were in the immediate area, all public school students would attend El Paso High, located at 800 East Schuster Avenue. In 1914, a contract was awarded to Henry and Gustavus Trost. By September 18, 1916, the Greco-Roman–inspired building opened its doors.

Although Austin Junior High School, Austin High School, and El Paso High School are not within the boundaries of MHHD, they did and still serve the needs of the community.

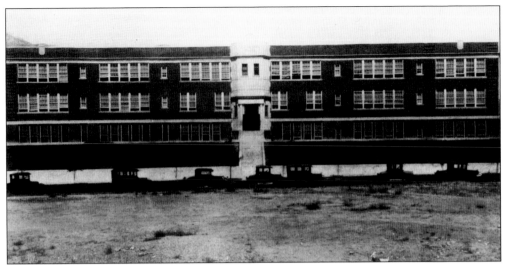

This image shows newly built Austin Junior High, which had been opened two years earlier to relieve overcrowding at Crockett Elementary. Soon after, apartments and homes would be constructed on the empty land in the foreground between Grant Avenue and the railroad tracks (not pictured). (Courtesy of EPISD.)

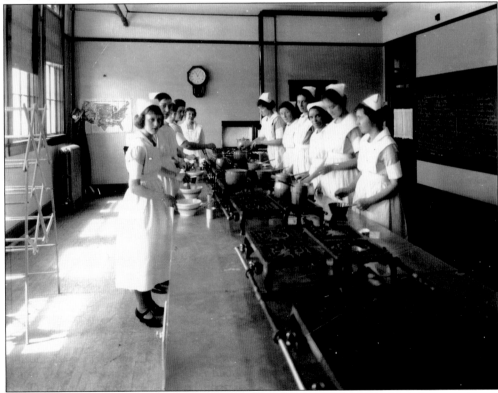

This image may have been taken late in the 1920s, when Austin Junior High became Austin High School. Just in time for lunch, as the clock reads 11:05 a.m., a teacher in the background on the left watches as cafeteria staff prepare the day's menu, including cream of tomato soup and soft custard, as written on the blackboard. (Courtesy of EPISD.)

In the 1929–1930 school year, members of the Girls' Booster Club pose for a picture with Portland Street behind them. This was the last year Austin High School was at this location, as a new school was being built. The two homes with two cars that can be seen behind the girls are 2731 and 2735 Portland Avenue. The house to the left is currently being remodeled and brought back to its original condition by Ray Rutledge. (Courtesy of El Paso Public Library.)

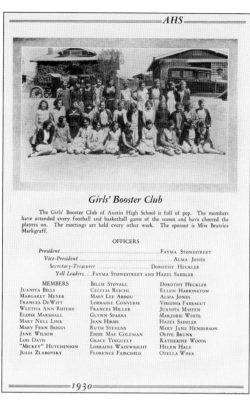

### Girls' Booster Club

The Girls' Booster Club of Austin High School is full of pep. The members have attended every football and basketball game of the season and have cheered the players on. The meetings are held every other week. The sponsor is Miss Beatrice Markgraff.

OFFICERS

President ......................................................... FAYMA STONESTREET
Vice-President ......................................................... ALMA JONES
Secretary-Treasurer ......................................................... DOROTHY HECKLER
Yell Leaders.....FAYMA STONESTREET AND HAZEL SADDLER

| MEMBERS | | |
| --- | --- | --- |
| | BILLIE STOVALL | DOROTHY HECKLER |
| JUANITA BILLS | CECELIA REICHL | ELLEN HARRINGTON |
| MARGARET MEYER | MARY LEE ABDOU | ALMA JONES |
| FRANCES DEWITT | LORRAINE CONVERSE | VIRGINIA FARRAGUT |
| WLETHA ANN RIHERD | FRANCES MILLER | JUANITA MASTEN |
| ELOISE MARSHALL | GLYNN SPARKS | MARJORIE WHITE |
| MARY NELL LINK | JEAN HIRSH | HAZEL SADDLER |
| MARY FERN BRIGGS | RUTH STEVENS | MARY JANE HENDERSON |
| JANE WILSON | EDDIE MAE COLEMAN | OLIVE BRUNK |
| LOIS DAVIS | GRACE TINGUELY | KATHERINE WOODS |
| "MICKEY" HUTCHINSON | LORRAINE WAINWRIGHT | HELEN HALE |
| JULIA ZLABOVSKY | FLORENCE FAIRCHILD | OTELLA WISER |

1930

The photographs show students doing what kids do best in their last year at the old Austin High School. Just toddlers at the end of World War I, they would be facing an uncertain future as October 29, 1929, rang in the Great Depression and World War II lay ahead. (Courtesy of El Paso Public Library.)

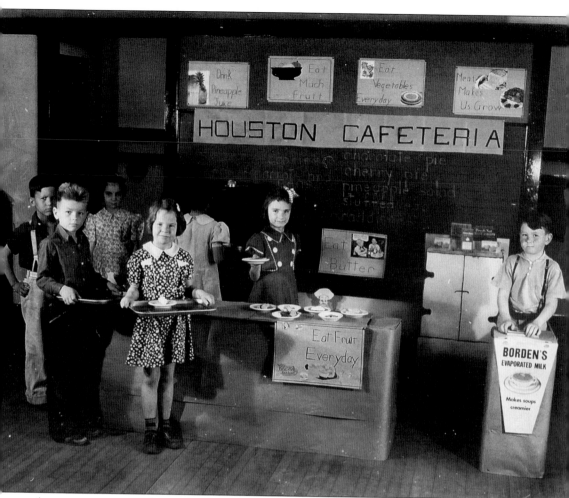

A new era once again began for the school on Grant Avenue as the school year began in 1930. Austin High would become Houston Elementary and continue to be so for 80 years until its closing in 2010. Here, students are learning the value of the basic food groups and eating healthy by running their own cafeteria. Much of the original building is still the same, and additions were added over the years to meet the needs of the community. The school building is currently going through the process of gaining a historic overlay for future generations. (Courtesy of Jeanette Lewis.)

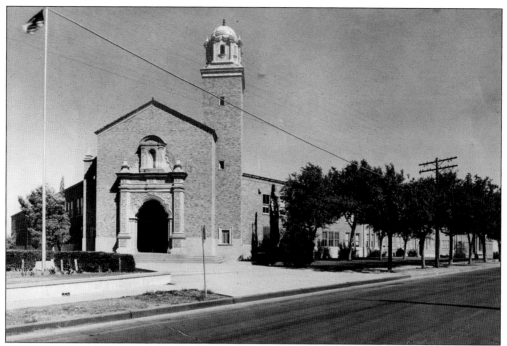

With the expansion of El Paso moving east and north, the old high school could no longer accommodate the number of students from growing neighborhoods. To meet the needs of the area, a new high school was built at 3500 Memphis Avenue. The student body chose to keep the name of its previous school, keeping the spirit of Austin alive. (Courtesy of EPISD.)

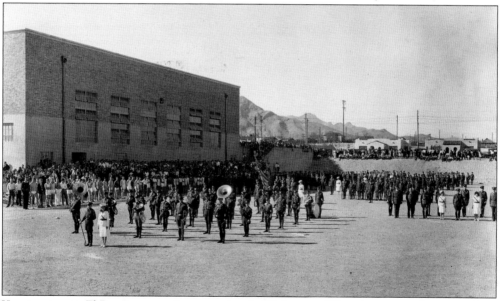

Keeping true to El Paso's progressive ways, Austin High, one of Texas' newest and most modern schools and built at a cost of $450,000, opened its doors in 1930. Only 14 years after El Paso High started its fall classes in 1916, Austin was ready for students. But it would not be long before Austin also began experiencing growing pains. This image near the gym shows the student body out watching cadets performing at the relatively new school. (Courtesy of EPISD.)

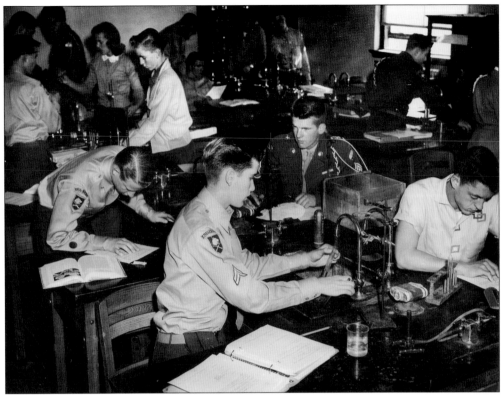

Students are posing in one of the science labs at Austin High School. They are working on a lab assignment without aprons or safety glasses. (Courtesy of EPISD.)

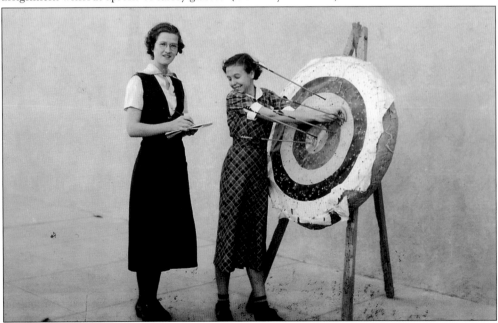

These unidentified young women are tallying the score and removing arrows from the target during a show of archery skills at Austin sometime in the 1930s. (Courtesy of EPISD.)

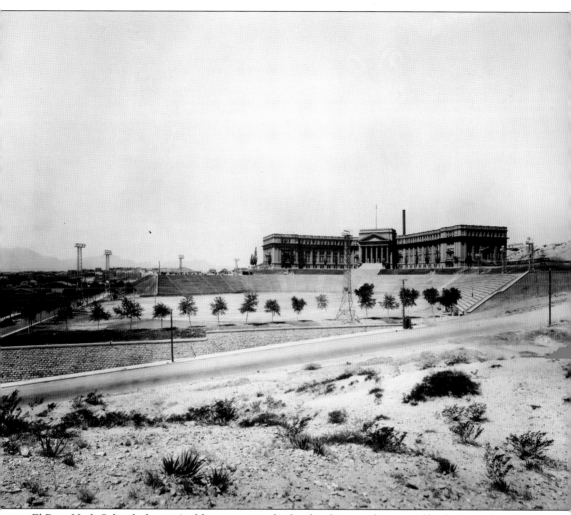

El Paso High School, the city's oldest operating high school, is standing proud high above the city. In this image taken five to ten years after it was built, the building looks more like a government building or grand library than a school. Henry and Gustavus Trost viewed other high schools around the country before coming up with this elaborate design. The first junior college in Texas held classes on the fourth floor beginning in 1920. The school opened in 1916 with 18 students and eventually had a total enrollment of 467 students during the 1926–1927 school year. In 1927, the junior college would merge with the School of Mines, now the University of Texas at El Paso. (Courtesy of EPISD.)

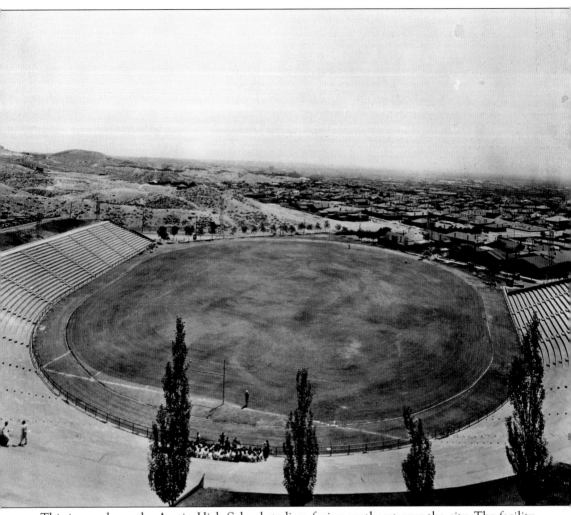

This image shows the Austin High School stadium facing southeast over the city. The facility sits directly in front of the main entrance of the school. With a seating capacity of 12,000, it was one of the first concrete stadiums built in the United States. Today, one can still sit where many others before did to watch football games, track meets, and graduations. (Courtesy of EPISD.)

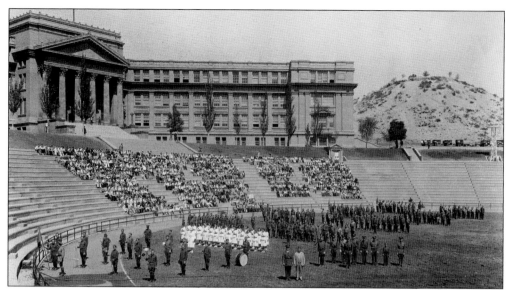

In 1866, Calvin Esterly, El Paso's first superintendent and a retired army officer and West Point graduate, introduced military training into the city schools. The corps would also be active in 1896 at Central High and organized once again in 1914, as tensions in both Europe and Mexico increased. This image was taken sometime after 1920, while the student body watches the review of the student military corps. The officer to the left directly in front appears to be Maj. Gen. Robert Lee Howze, a Medal of Honor winner who was at Fort Bliss from 1919 to 1925. (Courtesy of EPISD.)

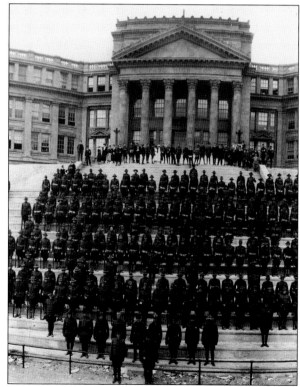

This image taken shortly after El Paso High School opened in 1916 shows Fort Bliss cavalry soldiers, possibly the 6th, 8th, 16th, and 20th infantry under the command of Brig. Gen. John J. Pershing which arrived in 1914. The officer in the second row, fifth from left appears to be Pershing himself. By 1916, more brigades arrived with two artillery battalions who were preparing to go after Pancho Villa. (Courtesy of EPISD.)

# Patrons Bulletin

Issued by City Schools of El Paso. Printed in Vocational School Print Shop
Published irregularly (two to four times a year) as a substitute for a book-form annual report.

| Volume II | El Paso, Texas, April 7, 1933 | Number 4 |

# 1933-34 BOARD OF EDUCATION

| HARVEY WILCOX | ROLAND HARWELL | C. C. COVINGTON | DR. GEO. TURNER |
|---|---|---|---|

R. Harvey Wilcox is president and manager of the Lone Star Motor Company. He is a native El

Roland Harwell is manager of the El Paso County Water Improvement district No. 1. He has resided in Texas for twenty years

C. C. Covington has been a resident of El Paso for the past 22 years as manager for the Graham Paper Company. In representing

Dr. George Turner, director of Turner's clinical laboratory, has been a resident of El Paso since 1919. He is a native Texan, born

Members of the 1933–1934 school board, C.C. Covington and Dr. George Turner both lived in the Manhattan Heights neighborhood at street addresses 1619 Elm Street and 3009 Silver Avenue, respectively. In 1922, members of the Ku Klux Klan had been elected to the school board and were responsible for changing the names of schools to honor heroes of the Texas Revolution. Manhattan School became Crockett Elementary, and El Paso High became known as Sam Houston High School for one year. By 1923, the Klan members were defeated, and El Paso High regained its name under public protest. (Courtesy of EPISD.)

# Seven

# St. Alban's

Known as the "Church on the Corner" at Elm Street and Wheeling Avenue, St. Alban's Episcopal would begin holding worship in an unfinished chapel in September 1921. In 1920, St. Clement's, which was established in 1870 and was the first Protestant church in El Paso, purchased the lot for $3,800. Contractor Robert E. McKee constructed the two-story stone-and-stucco structure for $13,493.86, and St. Alban's, a mission of the Church of St. Clement, would hold its dedication December 11, 1921.

Before there was a pool at Memorial Park, St. Alban's had one for the entire neighborhood to use. By 1942, after 21 years of use, a new church was needed and in 1944, Frazer and Benner drew up plans for the new St. Alban's to be built alongside the original. Robert E. McKee would once again be enlisted to construct the church at cost, and on October 2, 1949, a ground-breaking ceremony was held.

In 1962, the original chapel built in 1921 and an adjoining house that served as the rectory in 1933 were torn down to make room for a new parish hall. The architect chosen to design the new addition was Garland & Hilles, and the structure was built by Ray Ward & Sons.

Many milestones in the history of the church were achieved after much determination. A quote from Rev. Adolph Stoy states, " St. Alban's has not been free from hardship and heartaches, often storm tossed incidents to the lack of needed money, yet because of stern determination on the part of all concerned, the difficulties when arising have always been surmounted."

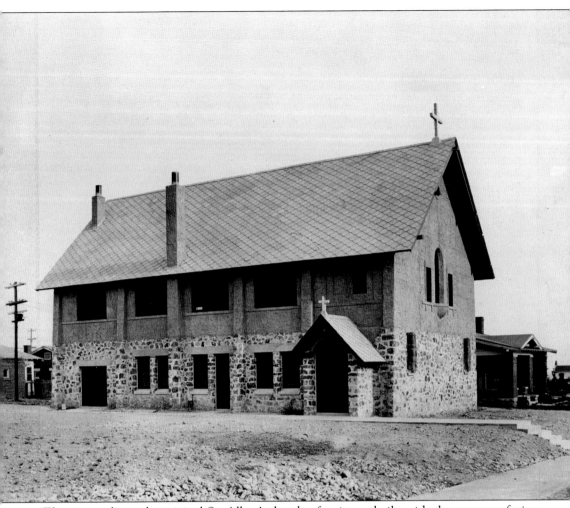

This image shows the original St. Alban's shortly after it was built, with the entrance facing Wheeling Avenue along with a dirt parking lot. The first floor was used to conduct Sunday school. The building had a kitchen and adjoining rooms that served as a residence for the clergyman and his family. The chapel was located on the second floor. Beginning in 1933, the house to the right and behind the church served as the rectory for a time. (Courtesy of St. Alban's Episcopal Church.)

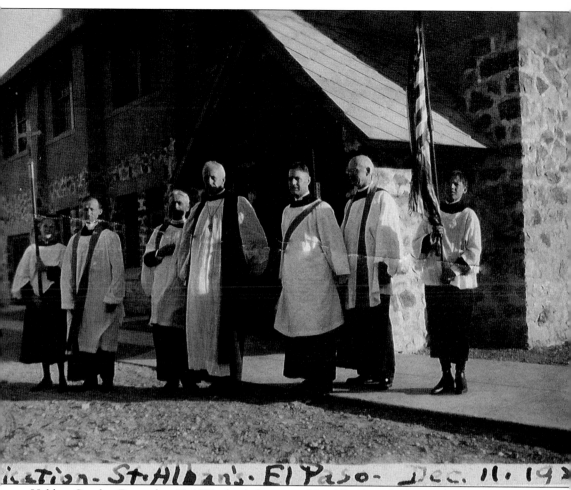

ication. St.Alban's. El Paso. Dec. 11. 19

Held on Sunday, December 11, 1921, the dedication of St. Alban's took place and was conducted by Bishop Frederick B. Howden, DD. In September 1921, Rev. Corwin C. Miller was appointed vicar and served until May 19, 1922, when he was transferred to Kingsville, Texas. Rev. B.M.G. Williams and Rev. C.S. Sargent would conduct services after Williams left. Six years after the dedication, Rev. Malcolm Twiss would come from the Diocese of Colorado and begin services on New Year's Day 1928. He would serve the church and the community of Manhattan Heights for 35 years and resigned on January 21, 1963. This photograph includes Rev. Malcolm Twiss (second from left), Rev. B.M.G. Williams (third from left), and Bishop Frederick B. Howden (fourth from left). (Courtesy of St. Alban's Episcopal Church.)

Born on December 10, 1869, in West Brighton, Staten Island, New York, Rev. Frederick Bingham Howden was made bishop of the Missionary District of New Mexico on January 14, 1914. He was married to Angelica Constance Faber on February 20, 1895. They had seven children, one of whom was named Frederick Bingham "Ted" Howden Jr., born on January 27, 1902. Ted would later be ordained by his father at St. Clement's in El Paso as a deacon on January 10, 1928, and a priest on January 13, 1929. He would later become a prisoner of war during the fall of Bataan in April 1942,. He survived the Bataan Death March only to die on December 11, 1942, at the Davao Prison Colony on Mindanao. (Courtesy of St. Alban's Episcopal Church.)

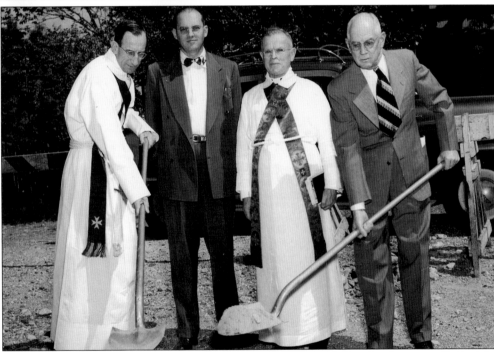

With the mortgage of the old church paid in full by August 1942, a fund was established for building a new church. Frazer and Benner's firm drew up the plans on April 30, 1944. In March 1949, a ground-breaking ceremony was conducted. Pictured are, from left to right, Rev. Malcolm N. Tiss, William Peticolas, Rev. Adolph A. Stoy, and O.W. Borrett. Borrett had given St. Alban's the original reredos (in back of the altar) that was hand-carved by 20 men, which had to be altered to fit the new church. Peticolas and Borrett were both pivotal in raising the funds needed to build the church when others thought it would be impossible from such a small group. (Courtesy of St. Alban's Episcopal Church.)

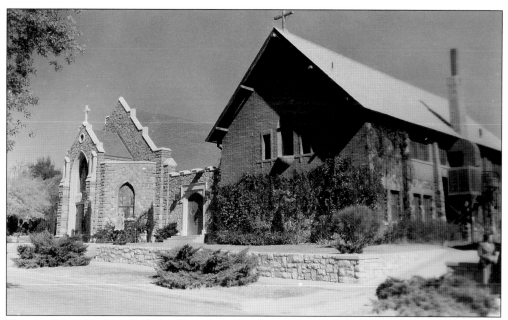

The new St. Alban's, called the Church on the Corner, opened its doors on December 3, 1950. Worship was conducted in the Vogel Chapel, which was donated in memory of Charles Edward Vogel by Mrs. Vogel. The past was erased 12 years later as the old original chapel and the rectory next door was demolished on May 25, 1962, to make room for the construction of the parish hall. (Courtesy of St. Alban's Episcopal Church.)

Bishop James Moss Stoney served as bishop of the District of New Mexico from 1942 to 1956. He was the last bishop of the Missionary District and the first of the Episcopal Diocese of the Rio Grande, which includes all of New Mexico and El Paso, Reeves, Culberson, Jeff Davis, Brewster, Presidio, Terrell, Hudspeth, and Pecos Counties in Texas. He married Nora Louise Green on February 16, 1926, and died in July 1965. (Courtesy of St. Alban's Episcopal Church.)

Between 1923 and 1928, a number of organizations and committees were formed at St. Alban's. The first bishop's committee was founded in May 1923. A women's auxiliary was organized with A. Louise Dietrich as president; she was also known as the "Desert Nightingale" and founded St. Mark's Hospital in 1908. The first men's club formed on January 8, 1924, with Dr. W.J.R. Akeroyd as chairman. The four girls pictured are members of the Girls' Friendly Society that was formed and organized in 1924. The two homes seen through the trees are located on Elm Street, with the far right house at 1815 Elm Street. St. Alban's purchased the residence from Mrs. Vogel to serve as the men's rectory. (Courtesy of St. Alban's Episcopal Church.)

Pictured downstairs in the old church is the Junior Choir of St. Alban's. When the new church was built, the old structure was used for educational and recreational purposes until a parish hall was completed. (Courtesy of St. Alban's Episcopal Church.)

Lucille Kimmell is shown on her wedding day with an unidentified man. St. Alban's has seen many weddings over the years. From its first annual report between May 1,1923, through December 21, 1923, there were 20 official recorded acts: seven baptisms, four marriages, five burials, and three confirmations. (Courtesy of St. Alban's Episcopal Church.)

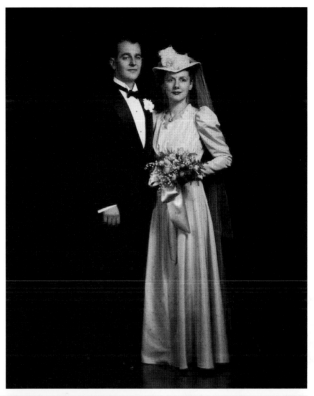

Members pose outside of the church on a windy day as the Italian cypresses, which still stand, blow in the breeze. Those present are an important part of St. Alban's. They are, from left to right, (first row) Helen Fulton, Nan Morrisette, unidentified, and Elaine Hupfer; (second row) Nancy Stanley, Laura Jagger, Rosemary King, ? Maury, Patricial Lunsford, Jay Amberg, ? Railston, Dorothy Laird (director), and Betty Hall; (third row) Rev. Adolf Stoy, Jackie Hall, Rev. Malcolm N. Twiss, Henry King, Lucille Kimmel, John Kimmel, unidentified, unidentified, and Haywood Hatfield. Helen Fulton was the organist, and A.F. "Nan" Morrisette was in charge of the Cradle Roll day care that started in September 1923 with 20 children. (Courtesy of St. Alban's Episcopal Church.)

This picture of the ordination of Thomas S. Bigelow was taken on May 16, 1964, in Kendrick Hall at St. Clement's Church. In 1920, $10,000 was allocated within the St. Clement's budget to construct the St. Alban's Mission in the Manhattan Heights subdivision, located in the fastest growing outskirts of town at the time. Representatives of many congregations in the Diocese of the Rio Grande are, from left to right, David B. Tod (St Paul's), Adolf Stoy (St. Alban's), Paul Habliston (St. Alban's), Kenneth C. Eade (St. Luke's), Alexander Blair (St. John's), Robert T. Gibson (St. Clement's), Kenneth L. Rice (St. Christopher's), Thomas Bigelow (St. Mark's), H. Eugene Myrick (St. Clement's), Bishop Charles James Kinsolving III (Sante Fe), James F. Kirkpatrick (St. Mark's), and Esteban Saucedo (St. Anne's) as well as Alton H. Stivers (rector of St. Jame's in New York). (Courtesy of St. Alban's Episcopal Church.)

Barbara C. Rhett is standing outside on a cold but sunny day sometime after 1950, when the church was completed and the grass had just filled in. By 1960, the mortgage was once again paid, the church would be consecrated on February 28, and more changes would soon occur. (Courtesy of St. Alban's Episcopal Church.)

St. Alban's sponsored and provided many sports activities for youths who lived in the area. There were the neighborhood swimming pool, basketball and softball teams, and tennis. In 1939, the St. Alban's team was city church league champions in basketball. In this Aultman image, the players pose for their championship photograph. They are, from left to right, (first row) Austin Crysler, unidentified, Bill Johnston, Ralph Parham, and the coach; (second row) Al O'Leary, Ross Borrett, Bud Lassiter, Jack Young, Jack Peden, and Jack Word. (Courtesy of St. Alban's Episcopal Church.)

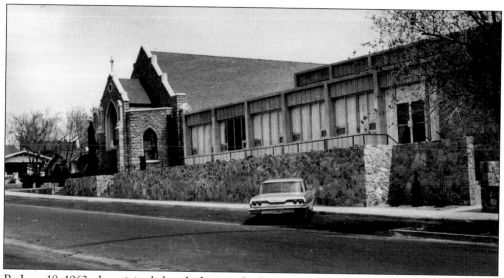

By June 18, 1962, the original church that was built in 1921 was gone, along with the house next door. The foundation for the new addition at the right was started on June 25, 1962. Ray Ward & Sons began construction, using plans from architect Garland & Hilles that same summer of 1962. Rev. Malcolm Twiss resigned, and Rev. Paul J. Hubliston was made rector on September 1, 1963. St. Alban's has celebrated its 90th year in El Paso. It seems to emulate a quote by church historian Janet W. Bartlett: "I have stood on the shores of the Lake of Galilee, where a soft breeze is blowing still, and there is a serenity that is unimaginable!" (Courtesy of St. Alban's Episcopal Church.)

At the time this picture was taken on January 9, 1949, Rev. Adolph A. Stoy was preaching a sermon upstairs in the original church; he was the deacon. By February 20, 1949, he would be ordained a priest, becoming St. Alban's associate rector as well as the church's first historian. On November 26, 1950, the last service was held in the old church. The following Sunday, the new church next door would open. Presently, Janet W. Bartlett is church historian. (Courtesy of St. Alban's Episcopal Church.)

*Eight*

# MANHATTAN PRESBYTERIAN AND FIRST CHURCH OF CHRIST, SCIENTIST

The beginnings of Manhattan Presbyterian Church go back to July 22, 1903, when O.G. Jones and 12 charter members held their first meeting at the corner of North Florence and Rio Grande Avenues. Westminster Presbyterian Church would be built on this site in 1911. By 1919, Dr. Watson Munford, the first pastor of Westminster, was at the helm. A new church built on the 1200 block of North Piedras Street officially opened its doors on April 12, 1921.

Constructed of hand-hewn bluish Mount Franklin limestone, the building began taking shape using architectural plans drawn up by Beutell and Hardie. Contractor John G. Lowman constructed the church, which cost $18,047.38.

In 1941, Andrew Byers took the initiative to bring to fruition a long-held dream of building a larger church, and by 1951, construction began. Robert Lowman the son of the original contractor took the task on of building the new church. Using plans created by the architect firm Monroe, Licht, and Higgins, the church was completed on October 3, 1954, at a cost of $135,000. The original stonecutter, Pascual Reyes, completed the work to the new addition almost entirely by himself.

Sometime in the early 1890s, the beginnings of the First Church of Christ, Scientist can be traced with the arrival of Minnie E. Barber. She was one of many who came to El Paso for medical reasons at this time. In 1885, George B. Wickersham arrived. Through Christian Science treatment, Barber was healed; from then on, the local society continued to grow. It was not until 1910, that they were able to build a permanent branch church on the corner of Stanton Street and Montana Avenue. After 17 years, and relocating to the Scottish Rite Auditorium, lots were purchased at the corner of Elm Street and San Diego Avenue in November 1931. Construction would begin in 1939. At a cost of $33,000, the new church would officially open its doors on May 19, 1940. It was built in stages, and as the years went by, a Sunday school, nursery, office, director's room, and reading room would occupy the premises. After many years of moving from one location to another, the First Church of Christ, Scientist found a permanent home at the corner of Elm Street and San Diego Avenue.

This building once located on the northwest corner of Montana Avenue and Stanton Street was the first permanent location for the First Church of Christ, Scientist and its home for 17 years. Two lots were purchased in January 1910 for $12,000, and the architectural firm Trost and Trost designed the structure. Contractor King Worley completed the church, with its 25-foot columns, for $10,000. It was ready for occupancy by June 19, 1910. (Courtesy of First Church of Christ, Scientist.)

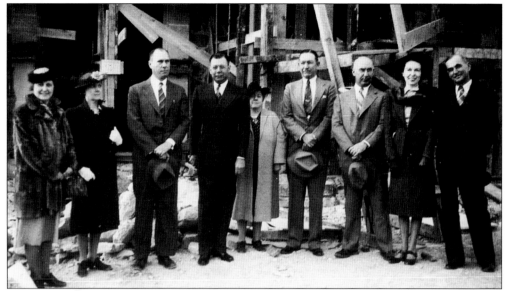

On April 2, 1940, the laying of the cornerstone for a new church located at San Diego Avenue and Elm Street took place. Standing outside of the front entrance of the church under construction are, from left to right, Myrtle Foster (treasurer), Martha Long (second reader), Austin Stevens (vice president), J. Cyril Edmondson (first reader), Clara S. Coffey (clerk), Frank Armstrong (board member), Gwyn Foster (chairman of the building committee), Dr. Pearl Ponsford (president), and Herbert Ethridge (board member). (Courtesy of First Church of Christ, Scientist.)

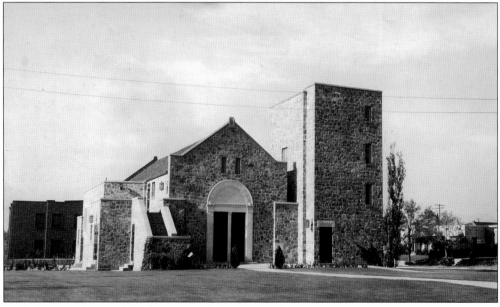

With the completion of the first stage of the church, the first services were held on May 19, 1940. Constructed of native stone and designed with Mediterranean influences, this portion of the Sovers and Spooner design consisted of the auditorium, reading soloists, and organist's rooms. The tower included offices, check, reading, distribution, and directors' rooms. To the left of the image are the apartments located on the corner of Elm Street and San Jose Avenue. (Courtesy of First Church of Christ, Scientist.)

After the First Church of Christ, Scientist was completely free of debt concerning the construction of stage one, a dedication was conducted on Sunday, April 28, 1946. This was six years after the first services were held. Two years later, plans were being voted on to begin stage two of the original architectural plans drawn up by Sovers and Spooner. (Both, courtesy of First Church of Christ, Scientist.)

*You and your friends are cordially*

*invited to attend the*

DEDICATION SERVICES

*of*

FIRST CHURCH OF CHRIST, SCIENTIST

*2800 San Diego Street*

*El Paso, Texas*

*Sunday, April 28, 1946*

*11 a.m. and 4 p.m.*

This November 1967 image shows the addition of the Sunday school. On June 4, 1948, the Ponsford Brothers presented a bid of $19,720 for construction. Built from the original plans, the Sunday school addition was constructed with the same native stone along with a red tiled roof. The Sunday school was ready for students by March 1949. (Courtesy of First Church of Christ, Scientist.)

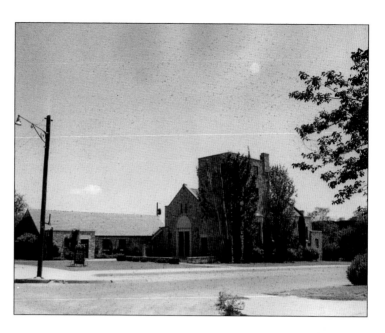

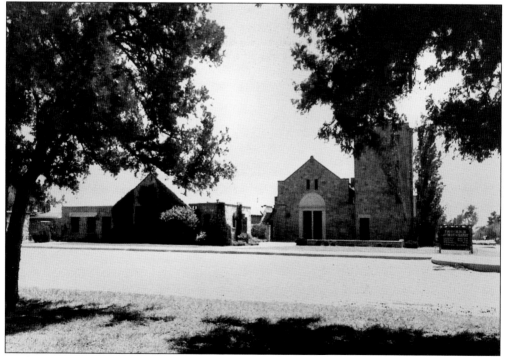

By the spring of 1951, a nursery was built onto the church. This last addition was approved for construction on February 25, 1965. It provided an office and a director's room, allowing for a separate street entrance away from the main building. From the beginning of purchasing the seven lots at the corner of Elm Street, construction was complete. (Courtesy of First Church of Christ, Scientist.)

Before the mother church in Boston recognizes a group of Christian Scientists as a branch church, a reading room must exist. This image shows the reading room that was once located at 306 Stanton Street. By 1977, the room was moved to its present location at the First Church of Christ, Scientist on San Diego Avenue. The earliest record of a reading room in El Paso is of one at 218 West Franklin Street in 1904. By 1908, it had moved to 610 East San Antonio Street and relocated to the Mills Building from 1910 to 1953. After 1953, it relocated to 306 Stanton Street, and it moved two more times—first, to 305 East Franklin and, finally, to the current location at 2800 San Diego Avenue. (Courtesy of First Church of Christ, Scientist.)

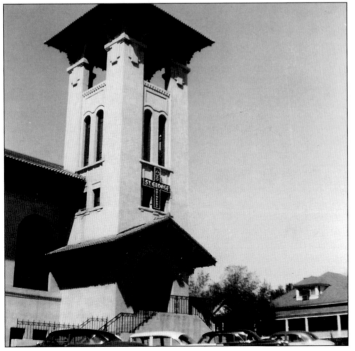

Located on the corner of North Florence and Rio Grande Streets, Westminster Presbyterian Church was built in 1911. O.G. Jones and 12 charter members organized it on July 22, 1903. The first pastor, Dr. Watson Mumford Fairley, would be the motivation for the eventual creation and building of Manhattan Presbyterian Church. This church would later be sold in 1951 to the St. George Antiochian Orthodox Church. (Courtesy of Manhattan Presbyterian Church.)

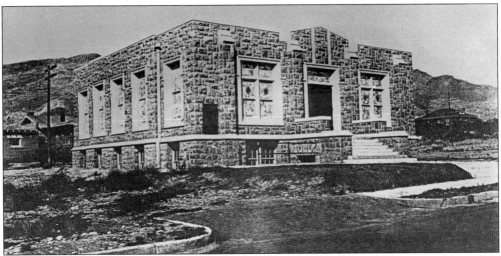

The dream began without any funds, and Fairley and others convinced the Home Mission in Atlanta, Georgia, to fund their idea. At the time, this was the rapidly growing Five Points District. This image shows the church after its opening in March 1921, with its completed first floor and basement. Construction had begun in June 1920. Two floors were originally planned but a second floor was delayed to a more favorable time. Stone for the church was originally from the Mount Franklin Quarries. A second story was begun on March 6, 1922, and finished in June of that year. (Courtesy of Jeanette Lewis.)

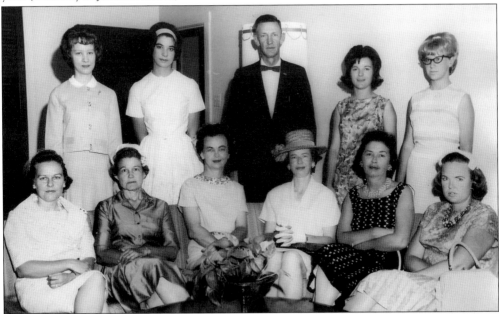

The girl standing in the second row, second from left is Francis "Frankie" Licht, daughter of Richard Licht of Monroe, Licht, and Higgins, the architectural firm responsible for designing the new sanctuary constructed in 1954. Richard also designed other buildings throughout El Paso, such as the Grace Lutheran Church, First Humane Society Animal Shelter, and the YMCA building on Montana Street. An artist, he was also the first president of the El Paso Art Association. He and wife Helen had four children—Barbara, Judy, Arthur, and Frankie. (Courtesy of Manhattan Presbyterian Church.)

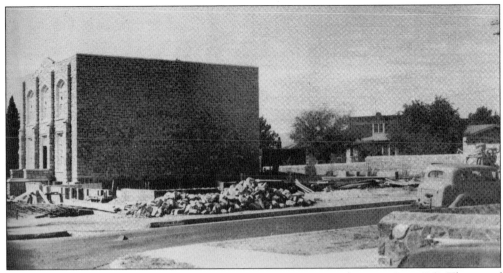

With a second story already added, construction of a new sanctuary began in June 1951. The son of the original builder, Robert D. Lowman, was contracted to build the new addition using the plans of architectural firm Monroe, Licht, and Higgins. With $75,000 in cash before construction began, there was one issue left to overcome—where to find the same stone used in the original structure. The Mount Franklin and Dudley quarries had been closed, since blasting was not longer allowed near Scenic Drive. Ultimately, all the rock that was needed was donated by the community and companies which rallied behind the endeavor. (Courtesy of Manhattan Presbyterian Church.)

Many pastors served Manhattan Presbyterian from the first, Dr. Ernest Trice Thompson, to today's pastor, Katherine Norvell. This 1956 image shows John Henry Justice standing at the front entrance of the almost two-year-old addition. Justice was born in Woodford, South Carolina, on February 14, 1910. He served in World War II as the staff chaplain of the all-black 45th combat engineering regiment in the China-Burma-India theater. Justice was wounded in 1944, while he was with his unit building the 1,024-mile Burma Road, according to a 1954 *Herald-Post* article. He was flown to William Beaumont Army Hospital for treatment. His injury almost resulted in a complete loss of hearing. J.H. Justice officially became pastor of Manhattan Presbyterian on March 10, 1946. (Courtesy of Manhattan Presbyterian Church.)

Pascual Reyes was born in Aguascalientes, Mexico. He learned his trade as a stonecutter from his father, Isabel Reyes, who built the Cathedral of San Antonio and many government buildings and personal estates. Reyes and his family relocated because of the 1910 revolt led by Francisco Madero that started the Mexican Revolution. In 1913, Reyes arrived in El Paso. He continued doing what he knew best and cut and laid the stones for the United States Post Office downtown in 1917. Over the years, he was employed as a mason who shaped the stones for El Paso High School, the College of Mines, and the many churches his chisel touched. This image taken in 1952 shows Reyes working with stone on the north wall of the church. (Courtesy of Manhattan Presbyterian Church.)

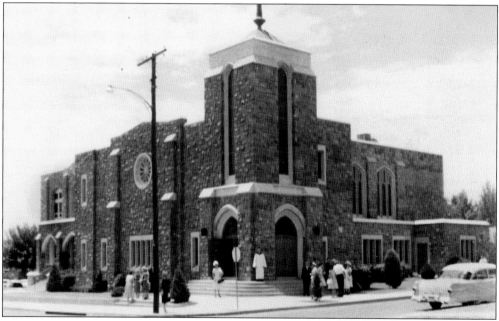

In this image taken in July 1961, ten years after the first stone was laid for the new addition, one can see the massive amount of stone required for the task. It came from many sources and was contributed from all over town. Mrs. W.L. Deal donated a large portion from her lots at Pershing Drive and Burch Street, which had ample quantities of stone, and stones from the homes demolished to make way for a new Safeway at Montana, Copia, and Tularosa Streets was given to the church by R.E. McKee. The Sears store located at Montana Avenue and Piedras Street, now the site of the Municipal Police Station, gave stone from homes razed to make room for a parking lot. R.D. Lowman's men gathered the remaining rocks from abandoned quarries. The original church, with the second story added, is at the far left. (Courtesy of Manhattan Presbyterian Church.)

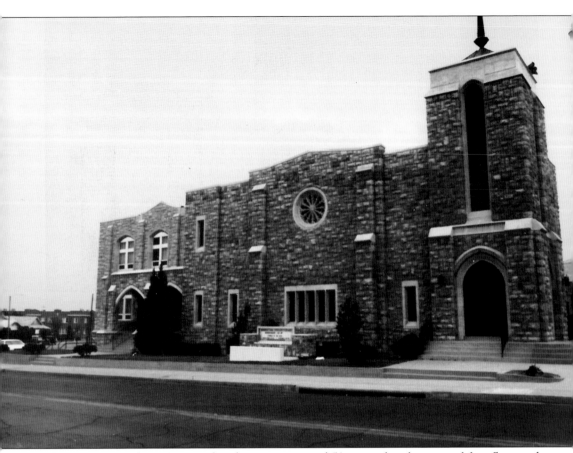

This image was taken 20 years after the expansion and 50 years after the original first floor and basement had been completed. It was entirely erected from hand-cut Mount Franklin stone that was shaped into 4-inch-by-8-inch and 8-inch-by-12-inch blocks. When construction began in June 1920, eight stonemasons were employed, and Pascual Reyes was one of them. By 1950, his services would once again be needed. Thought to be El Paso's last surviving stonecutter, Reyes, then in his 60s, would solely lay and shape every stone for the new addition with the aid of his helper Manuel "Korea" Martinez. With the men using a hammer and two chisels, the stonework took three years to complete. Manhattan Presbyterian was the last church Reyes worked on, as he retired only to build a third home for his family at 1008 South Oregon Street. (Courtesy of Manhattan Presbyterian Church.)

By 1939, the need for a larger church was being discussed. In May 1941, Andrew Byers, who was a pastor of Manhattan Presbyterian from 1941 to 1944, began a committee to study ways of raising the necessary funds to build a new church to meet the requirements of the growing congregation. Ultimately, it was realized that the only way to raise the necessary funds was through donations from friends and members of the church. World War II ultimately delayed the building of a new church, but the dream was realized 10 years later for the 654 members of the church. Construction began in June 1951. These images represent just two of the many Sunday school classes and children at Manhattan Presbyterian in 1938. (Courtesy of Manhattan Presbyterian Church.)

Manhattan Presbyterian sponsored the first Boy Scout troop that was organized in El Paso. Scoutmaster W.D. Gilland held the first meeting on Friday, September 16, 1921. Within seven years, and due to the large number of recruits, troop no. 16 was organized by the church, with the help of scoutmaster J.C. Hudson. Hudson was the driving force in constructing the Scout Hut, with three windows. This image on the south side of the church was taken in 1956, and it shows the hut along with the garage (with low roofline) that was built in 1951. Nelson Spence helped with construction, and along with others, built a four-wheeled trailer that was housed within. (Courtesy of Manhattan Presbyterian Church.)

Six men are sitting inside the hut built for the Boy Scouts in 1928. J.C. Hudson made a rough drawing and hoped to obtain enough material to build the structure from contractor Hugh McMillan. McMillan did more than supply the stone; he had his own men build it at no cost. R.E. McKee and Robert Lowman donated the cement for the floor. By the time all was said and done, the Scouts had a $3,000 hut that was constructed free of charge. (Courtesy of Manhattan Presbyterian Church.)

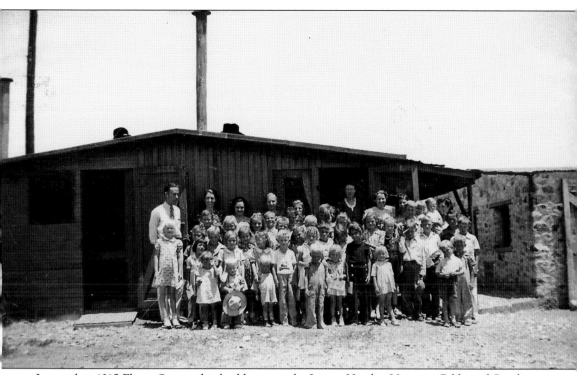

Located at 4015 Florey Street, this building was the Logan Heights Vacation Bible and Sunday school outpost. It opened on Christmas Day in 1939. After a renovation, 25 children and 23 adults attended the opening of the Logan Heights Chapel. Taken in the summer of 1941, this image shows the Manhattan Presbyterian members and many of the children who were served by the church. The members are, from left to right, (fourth row) Alfred Seddon, Mrs. Oswald Copper, Mrs. Harriet Stemson, Mrs. Clyde Black, Mrs. Rose Maria Holman, Mrs. Beatrice Gray (in the doorway), Mary Ella Banks, Mrs. E. Combs, and Mrs. Alfred Seddon. The children are unidentified. (Courtesy of Manhattan Presbyterian Church.)

Mary Ella and Mary Etta Banks arrived in El Paso, Texas, in July 1914. Born in Star City, Arkansas, on September 23, 1910, they spent their entire lives serving the community through the church by teaching Sunday school from the time they were 15 years old and also sang in the choir together. They never wanted to be separated from each other and taught fourth grade at Roosevelt School for 34 years in adjoining rooms. (Courtesy of Manhattan Presbyterian Church.)

George and Mary Wilson are pictured standing on their porch with their children in 1920. The Wilson family was one of the earliest that was part of the "multiplying by dividing" policy of Dr. Watson Mumford Fairley. Westminster had a membership of 393 adults with a Sunday school enrollment of 410 students. After Manhattan Presbyterian was opened and ready to conduct services, the task of determining who would become members of the new church and where the boundaries would begin posed a problem. It was later suggested by Fairley that those living east of Cotton Avenue would go to Manhattan. A new period in the history of the Presbyterian Church in El Paso began. (Courtesy of Manhattan Presbyterian Church.)

# Nine

# PEOPLE

As with any neighborhood, it is not the homes, schools, churches, or even businesses that define community. It is the people, because without them, the rest would not follow. J.F. and O.C. Coles and developer James Brady, who purchased the land, saw in the area an opportunity to develop a residential quarter. Once individuals and families purchased lots to construct their homes and architects and contractors designed and constructed them throughout the neighborhood, the homes, churches, and schools followed. The infrastructure needed as the population increased with included paved streets, utilities, security, and the park that would serve the population. As Rodney O. Davenport, who lived on Lebanon Avenue as a child, and his father, who owned a service station on the corner of Richmond Avenue and Piedras Street recalled, "It was a nice neighborhood, well-liked; everybody knew each other, and we were all friends."

From the beginning of the first home constructed in 1914 until the late 1920s, much of what was built was for the wealthy in El Paso. Many of the residences were large and opulent, to reflect wealth and position prior to the Great Depression. But before this, the ever-popular bungalows began filling the lots between and around the larger homes. It was then as it is today, a homogeneous group of professionals and working-class citizens. It has always and continues to be a cohesive group of people in all types of fields and who are still well-liked and continue to be friends.

The people have created a neighborhood, and they are what define it. However, the homes with their front porches where people still gather is what keeps it a wonderful place. The tree-lined streets allow one to walk around. The Texas Mountain Trail website considers it among El Paso's "most walkable neighborhoods as well as bikeable." There is the park in which to enjoy and celebrate birthdays and holidays with neighbors and family and a sense of community that brings people together.

Mayor Fred Hervey, sitting at the desk during a signing ceremony with unidentified individuals, spent his childhood and early adulthood living with his parents at 1501 Elm Street. He dropped out of high school during the Great Depression to help support his family. Hervey opened up a curbside root-beer stand and later served in the Navy during World War II. He also ran for Congress and lost in 1951, was mayor of El Paso from 1951 to 1955, and was reelected for a third term in 1973. Hervey was also the founder of the nation's second-largest convenience store chain, Circle K. (Courtesy of EPISD.)

Born in San Augustine, Texas, on October 8, 1886, Roy Hoard became a telegraph operator at 18 years old. While in Lufkin, Texas, he was diagnosed with tuberculosis. Advised like many others to move to El Paso, he did in 1910. Hoard was hired by Ferrocarril Noroeste de México (Mexico Northwestern Railway), which was organized by Dr. F.D. Pearson, who also owned the Madera Lumber Co. Ltd. Hoard became president of both companies. He was an integral force in keeping the railroad running during the Mexican Revolution. (Courtesy of Francis Jackson.)

Roy Hoard and Ruth Tisdale (pictured) from Baton Rouge, Louisiana, married in 1922. In 1929, they built the home at 3038 Federal Avenue and raised six children. In 1915, Roy was taken by Pancho Villa along with other Americans and was held for $300,000 ransom. Of the 56 Americans, 39 made it back to the States. During the Santa Ysabel Massacre, 17 of them chose to go to Cusi (Cusihuiriachi, Mexico) for work. On the way there, the train was attacked, and all but one of the Americans were killed. (Courtesy of Francis Jackson.)

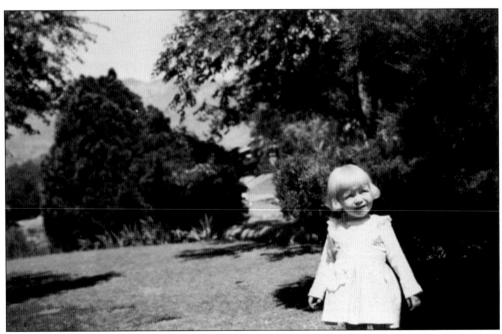

This picture was taken of little Francis Hoard at the Hill Top Gardens area in Memorial Park. She later attended Austin High School, where movie star Bing Crosby selected her as the "most beautiful" in January 1934. Two years later, while attending the College of Mines as a sophomore, she was elected the most beautiful girl by the editorial staff of the *Flowsheet*. (Francis Jackson.)

This picture taken in the front yard of 3020 Wheeling Avenue shows the Hoard children—Ellen Marie, Frances, Dorothy, Ruth, Claire, and Roy Carl—and an unidentified girl before 1929. The Hoards outgrew this home in 1923. Needing more room, the family moved to a new residence at 3038 Federal Avenue, constructed in 1929. The homes across the street are, from left, 3027 Wheeling Avenue, built for H.B. Harding in 1925; 3031 Wheeling, constructed for W.S. McMath in 1920; and 3101 Wheeling, built for G.B. Evans in 1916. (Courtesy of Francis Jackson.)

The Hoard family and relatives celebrate Christmas in the living room of 3038 Federal Avenue. At one time during the Mexican Revolution, Villa had taken Roy Hoard, Al Parks, and Barnum for ransom, all from the Madera Company. It was reported the ransom was paid, and all were set free. Roy and Ruth never had any biological children of their own, but their foster children, adopted son, and friends made life more enjoyable for them. (Courtesy of Francis Jackson.)

The home at 3027 Wheeling Avenue was first built for H.B. Harding. The second owner was Nadine Prestwood, who was an instructor of education at the University of Texas at El Paso. Her son Hugh Prestwood Jr. was inducted into the Nashville Songwriters Hall of Fame in 2006. Judy Collins recorded his first hit song, "Hard Time for Lovers," in 1978. Hugh Jr. has written no. 1 hits for many country stars such as Crystal Gayle, Trisha Yearwood, Randy Travis, and many others. The home at 3031 Wheeling Avenue, next to the empty lot, was built for W.S. McMath, owner of McMath Printing. (Courtesy of Francis Jackson.)

Standing in her grandmother's backyard on the 1500 block of Yandell Street, Henrietta Reynaud poses with a bow on her head. She was born on August 30, 1912. Her grandmother Eoline Glenmore Adams wrote the following poem for her: "She's Bon Mama's baby blossom and aunt Ora's Doodle Bug / Yayee calls her Billy Possum when she is stretched out on the rug / but her name is Henrietta so I heard her mother say / Gates and Jr. love to pet her 'cause she's one times one today." (Courtesy of Henrietta Reynaud Owen.)

Pictured are Henrietta and her brother William, horseback riding in Cloudcroft, New Mexico, and escaping the El Paso summer heat. Henrietta remembers taking the open-air train to Cloudcroft and how for entertainment people would jump off the train, run down the canyon, and run up and get back on the train. (Courtesy of Henrietta Reynaud Owen.)

Here are Henrietta and her brother William in the backyard of 3240 Lebanon Avenue. Although not in the Manhattan Heights District, she recalls when she went to Manhattan Heights School (later Crockett Elementary), she would jump the fence facing the alley, cross the alley, and go between the two homes located on Aurora Avenue. (Courtesy of Henrietta Reynaud Owen.)

Here are Henrietta and her family spending some time in Venice Beach in 1918, just after she survived the 1918 influenza epidemic. Her father, Henry Favort Reynaud, was a Frenchman from Louisiana who was sent to El Paso because he was thought to have tuberculosis. He stayed and married Annie Adams. Henrietta remembers walking through the park to the open-air theater, watching the park being built, and taking the trolley to school. (Courtesy of Henrietta Reynaud Owen.)

Pictured are Sandra Day O'Connor and Henrietta Reynaud Owen in 1981. At the time, O'Connor became the first female associate justice of Supreme Court of the United States. O'Connor was born in El Paso, Texas, and lived at 3113 Federal Avenue when she attended Radford High School and graduated from Austin High School. (Courtesy of Henrietta Reynaud Owen.)

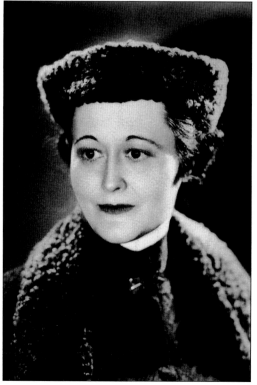

In the 1930s, Fae Huttenlocher was part of the movement for the beautification of America. She was the associate editor of *Better Homes and Gardens*, an author, a lecturer, and a leading authority on garden clubs in America. She came to El Paso on May 10, 1938, to present the Better Homes and Gardens Award to the city and a certificate of merit to Mrs. Maurice Schwartz in recognition of her award-winning English garden. (Courtesy of Jan Capecelatro.)

Fae Huttenlocher is in a garden cutting flowers. There were 2,000 entries competing for the Better Homes and Gardens Award, and El Paso was one of three that were selected. Huttenlocher was quoted as saying, "If people elsewhere knew how hard it was for El Paso to create this beauty spot, they would be ashamed. In other places, nature does two-thirds of the work." (Courtesy of Jan Capecelatro.)

Dr. William Compere Basom was one of the original founders of the El Paso Orthopedic Surgery Group in 1939. He served on many boards, published a large number of articles in medical journals, and served as an Army doctor during World War II. Basom resided at 3237 Aurora Avenue with his family until his death in 2000. Pictured are Dr. Basom, his wife, Maurine, and their sons, William Austin and Robert Compere Basom. Maurine collected much of the data regarding the homes on Aurora in order to obtain historic status for them. (Courtesy of Manhattan Presbyterian Church.)

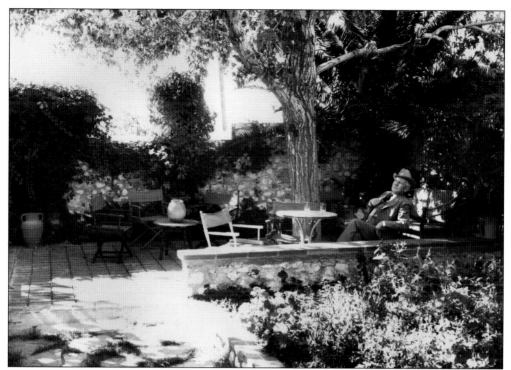

Many of the yards in the Manhattan Heights District were well maintained and an oasis from the heat. This image shows Roy Hoard enjoying his backyard at 3038 Federal Avenue. (Courtesy of the Blumenthal Collection at the El Paso Public Library.)

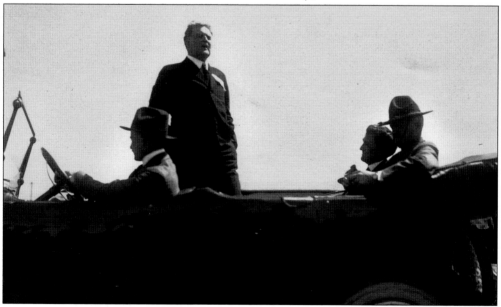

Sitting in the backseat with his hat on is General Pershing with unidentified men who closely resembles the Dudleys standing and sitting next to him. Pershing was a frequent guest of the Leavells at 3037 Federal Avenue. Troops can be seen reflected on the car. (Courtesy of El Paso Public Library.)

This photograph was taken in the backyard of 3121 Copper Avenue. Standing is James Dudley, and on the bench is believed to be William Dudley. James, William, and Richard Dudley began a construction company in Chihuahua, Mexico, in 1898. They moved to El Paso in 1911 and played a large part in developing El Paso and the rest of Texas, as well New Mexico, Arizona, and Mexico. The Dudleys built tracks for the Mexico Northwestern Railway, Cumbre Tunnel, a portion of the Parral & Durango Railroad, and the Chihuahua-Pacific Railroad. (Courtesy of Richard and Frances Moore Dudley Papers, C.L. Sonnichsen Special Collections Department, University Library, the University of Texas at El Paso.)

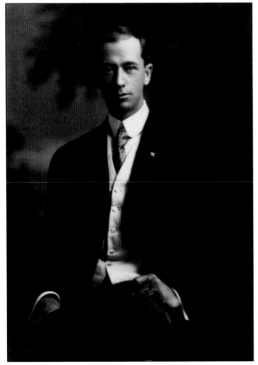

Charles H. Leavell was born in Jewett, Texas, on January 7, 1876. He served in the Spanish-American War in 1898 with the first Texas infantry and arrived in El Paso in 1902. In 1903, Leavell started a cattle ranch in El Paso County that he ran until 1907. He sold the ranch, eventually went into the real estate business, and is responsible for developing Manhattan Heights and building the first home at 3037 Federal Avenue. In 1936, Leavell passed away of a cerebral hemorrhage at 60 years old. (Courtesy of Stout-Feldman Studio Photographs, C.L. Sonnichsen Special Collections Department, University Library, the University of Texas at El Paso.)

In 1899, J.C. Peyton made his way to El Paso. At 21 years old, he was diagnosed with an advance case of tuberculosis from Lebanon, Tennessee. He recovered, and Joe Peyton founded the Peyton Packing Company. In 1917, he opened Peyton Packing Company, the most modern and sanitary plant at the time, with three days shipping. It was considered one of the most important businesses in the area. (Courtesy of Stout-Feldman Studio Photographs, C.L. Sonnichsen Special Collections Department, University Library, the University of Texas at El Paso.)

Fred J. Feldman was the owner of Fred J. Feldman Co. Inc., a photographic and sporting goods store at 308 E. San Antonio St. He was born in San Jose, California, on July 29, 1872. He lived in Tucson, Arizona, until moving to El Paso in 1895. Considered to be the leading photographer in the southwest, he went into business with J.C. Bushong, eventually buying him out. He passed away at his home on 1407 Elm Street of a brain hemorrhage (Courtesy of Stout-Feldman Studio Photographs, C.L. Sonnichsen Special Collections Department, University Library, the University of Texas at El Paso.)

Rabbi Martin Zielonka arrived in El Paso on September 6, 1900, along with his wife, to serve as the rabbi for the Temple Mount Sinai, located at Oregon and Yandell Streets. He was born in Berlin on February 15, 1877, and immigrated to the United States at three years old. He was very active with the community, serving as president of the Memorial Park plan. He also organized the first junior college in El Paso, which was located at El Paso High School until merging with the School of Mines, now the University of Texas at El Paso. He organized the first recreational club room in the country at San Antonio and Kansas Streets, serving Jewish soldiers stationed at Fort Bliss. (Courtesy of Stout-Feldman Studio Photographs, C.L. Sonnichsen Special Collections Department, University Library, the University of Texas at El Paso.)

Working in the backyard of 1508 Elm Street in the 1950s is Robert Light, when he was approximately 15 years old. Robert would grow up and work for the highway department in Austin. (Courtesy of Helen Niemeier.)

# *Ten*

# CONTRIBUTING FACTORS

The area began changing with development of homes and schools, construction of churches, a park, and the ease of transportation. Trolleys traveled along Piedras and Copia Streets. More people began moving in, and the surrounding area grew. The only private business to function in what now is MHHD was the Texas Company gas station located on the corner of Grant Avenue and Elm Street. This station still stands today and has been completely renovated by Rodney O. Davenport, who waited 35 years to purchase the building. The city is also adding a small pocket park adjacent to the building. Someday soon, the old station may once again reopen and serve something other than gasoline.

Many who lived and contributed to the Manhattan Heights neighborhood were also part of a large, driving force for the city as a whole. The doctors who resided in the area, such as Robert Homan, constructed the Homan Sanatorium at the corner of Cotton and Erie Street. Dr. Willard Schuessler, who lived at 3007 Copper Avenue and became a well-known plastic surgeon, helped many World War II veterans and went into private practice later. His wife, Louise, was organizing chairman of the El Paso Historical Society. The Dudleys who owned Dudley Quarry, now the location of the police academy on Scenic Drive, supplied much of the stone that became the foundations of many of the buildings, homes, and walls in the early days. Flint McGregor, whose father was a wealthy rancher, later sold the property to the military. It still bears the family name and is known to many as McGregor Range. The Gunning-Casteel Drug store owner Tom Gunning resided at 3121 Copper Avenue. The home of his partner, Wylie Casteel, was a few houses down at 3101 Copper Avenue.

Just as the neighborhood has had many individuals who contributed and left their marks in El Paso as well as on the nation, it still has doctors, lawyers, business owners, teachers, plumbers, nurses, artists, and newscasters who are also a pivotal part of Manhattan Heights and are creating their own legacy for future generations.

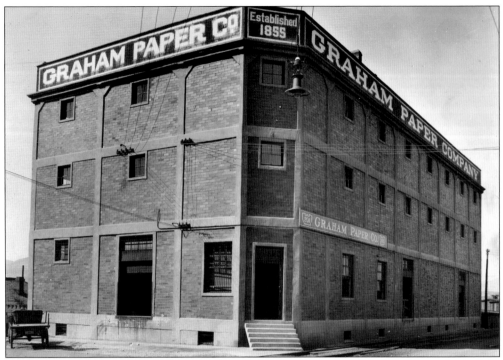

Located at 201 Anthony Street, this building was the Graham Paper Company, which C.C. Covington spent many years working for. (Courtesy of the University of Texas at El Paso.)

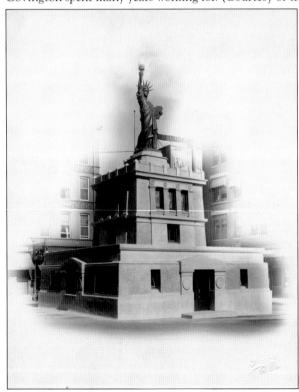

This statue located across the street from the Sheldon Hotel represented the spirit of El Paso at the time. The Statue of Liberty in El Paso, Texas, was liberty enlightening the west as the original in New York Harbor was enlightening the world. El Paso was a rapidly growing, progressive city, known as the "New York of the desert." This Otto Thorman creation closely resembles the original and the base itself has many of the architectural details of the original. (Courtesy of Otto H. Thorman Architectural Records, C.L. Sonnichsen Special Collections Department, University Library, the University of Texas at El Paso.)

The president of Dudley Stone Products, James Marvin Dudley, resided at this house across form Memorial Park at 3121 Copper Avenue. Besides being a builder of railroads and highways throughout the Southwest, he was also the man responsible for building Scenic Drive along the Franklin Mountains. The Dudley Quarry is now the location of the El Paso Police Department Academy. The home to the right, at 3117 Copper Avenue, belonged to Dr. Robert and Alice Homan. Dr. Homan and his father owned the Homan Tuberculosis Hospital that still stands today. (Courtesy of Richard and Frances Moore Dudley Papers, C.L. Sonnichsen Special Collections, University Library, the University of Texas at El Paso.)

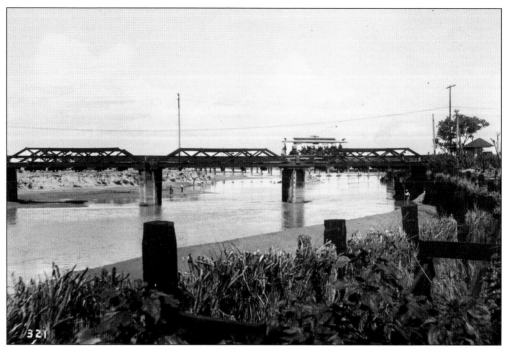

This is the bridge from El Paso to Juarez, Mexico, that was eventually torn down. The beams found their way into many of the homes that Mabel Welch and Otto Thorman built in Manhattan Heights and other parts of town. (Courtesy of El Paso Public Library.)

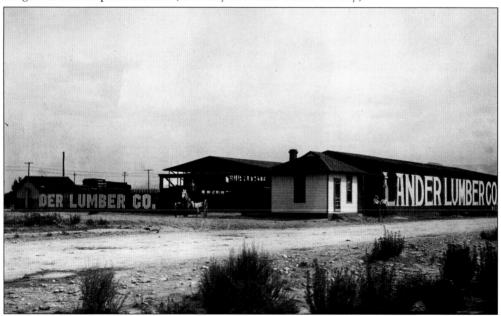

This picture was taken in 1909 of the Lander Building, located at 1700 Texas Street on the southwest corner of Laurel. It was owned by Robert Lander. He arrived in El Paso in 1906 and founded the lumber company in 1908. The home at 2923 Silver Avenue was designed by Gertrude Attaway and constructed by John C. McElroy for Robert Lander in 1916. (Courtesy of El Paso Public Library.)

Once located at 918 Piedras Street, the Masonic Hospital served the growing eastern part of town until it was torn down to make room for a Sears department store, which was in operation until 1981. (Courtesy of El Paso Public Library.)

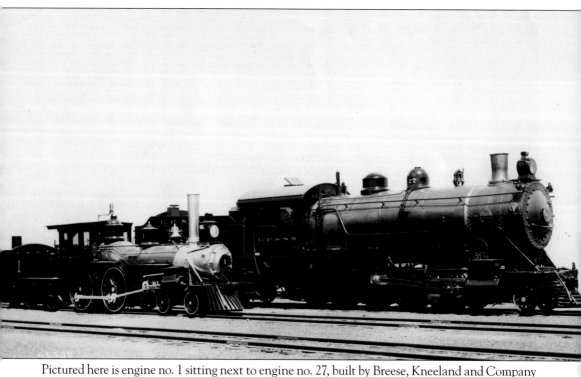

Pictured here is engine no. 1 sitting next to engine no. 27, built by Breese, Kneeland and Company of Jersey City, New Jersey, in 1857. No. 1 was retired in 1909 and, after the Southern Pacific Railroad acquired the locomotive, sat in a park located at Stanton and Franklin Streets for 50 years. In 1938, it made its film debut in the Metro-Goldwyn-Mayer movie *Let Freedom Ring*. In 1960, it was moved to the University of Texas at El Paso for 40 years. In 2001, $2.2 million was raised to move and restore the engine. It was recognized as a National Trust for Historic Preservation Save America's Treasures project. Today, the completely restored engine resides at the Railroad and Transportation Museum of El Paso. It is one of only 30 engines of that time period that has survived. (Courtesy of El Paso Public Library.)

Located at 3144 Wheeling Avenue, this home was constructed by Trost and Trost for Flint
McGregor in 1922. McGregor is the son of Dr. John Douglas McGregor, who resided at 3025
Aurora Avenue. John never practiced medicine, but along with his three sons, he owned Corralitos
Ranch between Las Cruces and Deming, New Mexico. He also owned what is now a part of White
Sands Missile Range, known as McGregor Range. The young girl sitting on the steps is Della
McGregor Gilmer, daughter of Flint and Terese McGregor. The McGregor coat of arms can still
be seen on the home. (Courtesy of El Paso Public Library.)

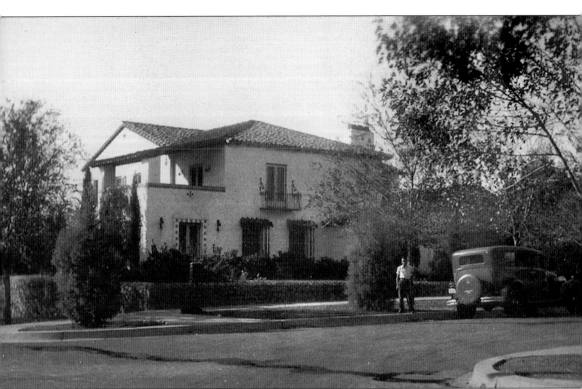

The home at 3038 Federal Avenue still belonged to the Hoards when this picture was taken. The second owners were Mr. and Mrs. Dorrance Roderick Jr., who along with Dorrance Sr. owned the radio and television station KROD, the Northgate shopping center, and the *El Paso Times*. The third owners were Ruth and Dr. Bill Reynolds, who were named El Paso's "Mother and Father of the Year" in 1970. Although Ruth dreamt of having 12 children, she knew she had found her man when Bill said, "I don't think we should put a limit on it." They had 13 children. (Courtesy of Francis Jackson.)

Contractor William Rheinheimer constructed this home at 3124 Aurora Avenue in 1917. William arrived in El Paso on September 5, 1881. He was born in Syracuse, New York, and married Elizabeth Nies. They had five children together. One of the children, Edward William Rheinheimer, became one of the few early doctors born in El Paso. Dr. E.W. Rheinheimer also lived in the home, and three generations of his family have at one time lived there. It is still owned by the family. (Courtesy of Marianne Schumaker.)

The great-granddaughter of contractor William Rheinheimer and granddaughter of Dr. Edward William Rheinheimer currently resides in this home at 3121 Wheeling Avenue. William Rheinheimer also constructed this house, right behind the one that he built on 3124 Aurora Avenue. Dr. E.W. Rheinheimer began his practice in El Paso in 1917, after he was rejected because of a heart condition when he tried to volunteer with the US Medical Corps. (Courtesy of Marianne Schumaker.)

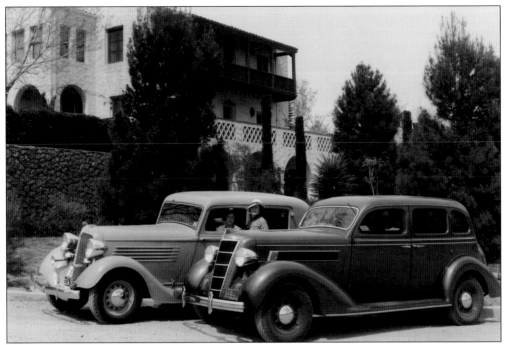

One of the unidentified women parked on the side of the house on Raynor Street, located at 3012 Silver Avenue, is thought to be the owner of the home. Raynor Street is still unpaved. (Courtesy of Chris and Tatjana Lane.)

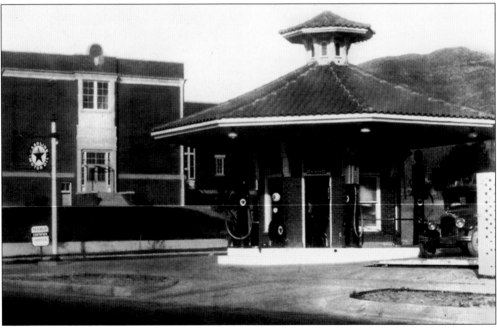

This gas station at the corner of Grant Avenue and Elm Street, now owned by Rodney Davenport, has been restored to its original condition, with replicas of old gas pumps. The streetlamps that are in the pocket park adjacent to the station were restored and donated to the city by Davenport. (Courtesy of Rodney Davenport.)

This photograph and the following five images were taken during the 1928 flood that took place in El Paso after a cloudburst that hit the area. These two vehicles stuck in the mud are located on Copia Street, just beyond the train overpass. On the bridge, one can see the cable supports for the trolley car line that once transported residences throughout town. (Courtesy of St. Alban's Episcopal Church.)

Large amounts of water flowing down the streets from the Franklin Mountains, as here on Wheeling Avenue, brought large amounts of dirt and rocks. This is at the corner of Wheeling Avenue and Elm Street. The house in the image is located at 1815 Elm Street. (Courtesy of St. Alban's Episcopal Church.)

This is Piedras Street, which was washed out due to the water on its way to the Rio Grande. (Courtesy of St. Alban's Episcopal Church.)

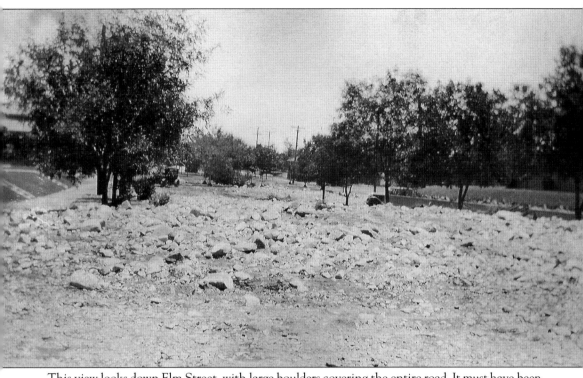

This view looks down Elm Street, with large boulders covering the entire road. It must have been a sight to see as it transformed into a raging river. Today, Elm Street occasionally becomes the "Elm River" during heavy rainfall. (Courtesy of St. Alban's Episcopal Church.)

A group of people has gathered under the train overpass to survey the damage along Copia Street. Mrs. Owen remembers the soda truck stuck in the mud when she was there at 16 years old. Right above the car, the Crockett School can just be made out above the hill. (Courtesy of St. Alban's Episcopal Church.)

This is St Alban's seven years after it was constructed in 1921. The water rushing down Wheeling Avenue continues to Piedras Street and also makes a bend down Elm Street. (Courtesy of St. Alban's Episcopal Church.)

Constructed in 1922 for Frank A. Hughes, this apartment house is located at 1414 North Piedras Street. Hughes was the manager of Chamberlin Metal Weather Stripping Company. This three-story complex has a basement, garages, and a small park next to it. (Courtesy of author.)

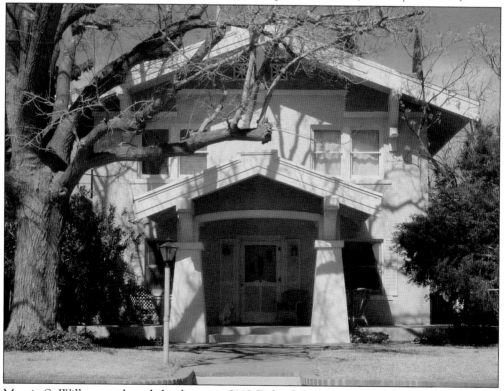

Mamie S. Wilkey purchased this home at 3113 Federal Avenue on June 13, 1943. Wilkey was the grandmother of Supreme Court associate justice Sandra Day O'Connor. Title to the house was shortly transferred to Wilkey's daughter Ada Mae Day, wife of Arizona Lazy B Ranch owner Harry A. Day. The Day's three children, including Sandra, lived with Wilkey in order to attend school in El Paso. (Courtesy of author.)

# www.arcadiapublishing.com

Discover books about the town where you grew up, the cities where your friends and families live, the town where your parents met, or even that retirement spot you've been dreaming about. Our Web site provides history lovers with exclusive deals, advanced notification about new titles, e-mail alerts of author events, and much more.

**MADE IN THE USA**

Arcadia Publishing, the leading local history publisher in the United States, is committed to making history accessible and meaningful through publishing books that celebrate and preserve the heritage of America's people and places. Consistent with our mission to preserve history on a local level, this book was printed in South Carolina on American-made paper and manufactured entirely in the United States.

This book carries the accredited Forest Stewardship Council (FSC) label and is printed on 100 percent FSC-certified paper. Products carrying the FSC label are independently certified to assure consumers that they come from forests that are managed to meet the social, economic, and ecological needs of present and future generations.

**FSC**
**Mixed Sources**
Product group from well-managed forests and other controlled sources

Cert no. SW-COC-001530
www.fsc.org
© 1996 Forest Stewardship Council

Find Your Place in History.